IMAGES
of America

CONEJO VALLEY

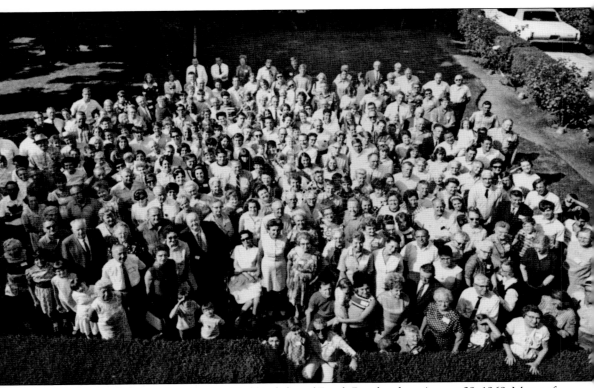

The Borchard clan gathers for the 83rd birthday of Frank Borchard on August 29, 1969. Many of the photographs for this book were taken from the photo albums of the people who were at this celebration. (Courtesy author's collection.)

ON THE COVER: The Borchard cousins take in a view from the Caspar Borchard Ranch in 1906. Pictured here are, from left to right, Eddie Maulhardt, Theresa Borchard Maulhardt, Rosa Borchard Kelley, Annie Borchard Friedrich (standing), Anna Kellner Borchard, and Ida Ayala Borchard. (Courtesy author's collection.)

IMAGES *of America*

CONEJO VALLEY

Jeffrey Wayne Maulhardt

ARCADIA
PUBLISHING

Published by Arcadia Publishing
Charleston SC, Chicago IL, Portsmouth NH, San Francisco CA

Printed in the United States of America

Library of Congress Control Number: 2009937671

For all general information contact Arcadia Publishing at:
Telephone 843-853-2070
Fax 843-853-0044
E-mail sales@arcadiapublishing.com
For customer service and orders:
Toll-Free 1-888-313-2665

Visit us on the Internet at www.arcadiapublishing.com

To my Borchard cousins,
who lent me their archives of photographs that allowed
me to tell a portion of Ventura County history:
Leslie Borchard Battijes, Margaret Borchard Bartel,
Gertrude Friedrich Becker, the Brawley Borchards,
Jim and Elsa Borchard, John Haidu Borchard,
Rita Borchard Edsall, Gloria Friedrich Jones,
Fay Borchard Mahan, Alice Borchard Fussell, and Mary Rydberg.

CONTENTS

Acknowledgments 6

Introduction 7

1. Pioneers 9

2. Homes, Barns, and Farms 31

3. The Landscape 41

4. Lakes, Streams, and Dams 59

5. Post Office Box, Schools, Hotels 79

6. Horse Power 93

7. Ladies of the Conejo 115

ACKNOWLEDGMENTS

I want to thank three organizations whose help and cooperation helped make this book possible. A big thanks goes to the Stagecoach Inn Museum and Conejo Valley Historical Society for allowing me to scan from their photograph archives. Specifically, I want to thank Sandy Hildebrandt and Miriam Sprankling.

Also, I am deeply indebted to the Thousand Oaks Library Special Collections Department, expressly to Jeanette Berard for her direction, knowledge, patience, and punctual responses. Jeanette recognized my time constraints and helped me to plug those last-minute gaps.

Another big thanks is deserved by "Big Al" Alison Maulhardt for running those errands that time did not permit.

Finally, I am beholden to Carol A. Bidwell and the late Pat Allen, who wrote the major sources for the body of this volume. *The Conejo Valley-Old and New Frontiers* by Carol A. Bidwell and Pat Allen's work on the *Ventura County Historical Society Quarterly*, "Conejo Valley: Bicentennial-Centennial," from the spring of 1976 edition, were invaluable as starting points and constant references.

Other sources used were Joseph Russell's *Cattle on the Conejo* and *Heads and Tails . . . Odds and Ends*; Patricia Russell Miller's *Tales of the Triunfo*; Miriam Sprankling's *Discovering the Story of Conejo Valley*; my own volumes, *The First Farmers of the Oxnard Plain* and *Beans, Beets & Babies*; and various county biographies by Yda Adds Stork, J. M. Guinn, Gidney, Brooks, and Sheridan.

The photographs selected for this book were not based on my family, even though many of them came from family members. Rather, the photograph selections were based on elucidating the themes and stories told. In every case, I tried to find "fresh" photographs, ones that were new to the Conejo publication canon. However, those duplicated from other publications were chosen to keep a balance or because there were no other choices. I hope you enjoy this marvelous history.

Unless otherwise noted, all images are courtesy of the author's collection.

INTRODUCTION

The history of the Conejo Valley dates back to the Chumash people, who lived peacefully in the area for approximately 10,000 years. The Spanish explorers were followed by a Rancho Period of several decades, which lead into the Ranch Period before giving way to the modern cities of today.

The Chumash utilized the Conejo Valley for all of its resources, including spring water, wild game, berries and acorns, the caves in the hillsides, and the valleys that lead back to the ocean. A dispute over the land came to a head during the Rancho Period when the Spanish and the natives clashed near the watering hole that became known for the word in Spanish that means triumph, Triunfo. However, a second reference to the origin of Triunfo was written by lifelong Conejo resident Joseph Russell, the author of two books about the area. Russell wrote that the name Triunfo came from the diary of Juan Crespi. The hot, famished, and lost Spanish entourage spotted the creek from atop a nearby peak and exclaimed "Triunfo." Whatever the case, the creek served as a source of rejoice for the Spanish and later the ranchers in the area.

It was the Spanish who came up with the name for the valley of rabbits, Conejo, the Spanish name for rabbit. And it was in 1803 that Jose Polanco and Ignacio Rodriguez were granted El Rancho Conejo by Gov. Jose Arrillaga. The area contained 48,671.56 acres. However, unlike the land granted after Mexico gained independence from Spain in 1821, whereby the grantee became the owner, the Spanish crown retained ownership of the granted estate. El Conejo was one of only two land grants in what became Ventura County (1873), the other being Rancho Simi. By 1822, Polanco's portion was granted to Jose de la Guerra y Noriega by California governor Pablo Vicente de Sola. A few years later, Gov. Jose Figueroa granted the Rodriquez portion to Maria del Carmen Rodriguez and her siblings. Gov. Juan Alvarado confirmed the grant during his tenure in 1839. The land transferred to the next generation during the American transition. The rancho was surveyed by the U.S. surveyor's office in 1861. After a series of appeals, the patent was finally issued in 1871 for the 48,671 acres and granted to Jose de la Guerra and the heirs of Ygnacio Rodriguez. This was the beginning stage of the Ranch Period of the Conejo.

The Ranch Period began in August 1871 when the de la Guerra family sold 23,835.75 acres to John Edwards and Howard W. Mills, both men living in Santa Barbara. At a cost of $55,000, Edwards and Mills paid $2.30 per acre. Land on the west side of the grade for the La Colonia grant was going for more than $10 an acre. However, the Conejo land attracted many Santa Barbara investors, many of whom came to the Goleta area in hopes of purchasing the subdivision of the large estate of Daniel Hill and the Rafaela Ortega de Hill estate that was advertised in the Northern California newspapers. Among the men who knew Edwards from the gold fields of Ione and who invested in Rancho El Conejo were Samuel Hill, Eugene P. Foster, and Joseph Sexton.

The remaining portion of the Conejo was in the hands of the Rodriguez heirs, who by the 1870s rose to more than 100 claimants. To purchase the rights from these claims, Edwards and Mills had to track down the owners of the remaining rancho, many of whom had sold their portion for

as little as $50. Egbert S. Newbury bought into the partnership for a nominal fee, and he came out with 2,259.20 acres. C. E. Huse bought 3,285 acres, and Carlos Garat retained 225.50 acres, while Jose del Rasane de Vidal and Francisco Vidal kept 47.67 acres each. The heirs to Miguel and Maria Manuela Peralta also retained 47 acres, and Anselmo Ortega took 88.40 acres, and the heirs of Maria Machado Reyes kept 250 acres.

Ultimately the major landowners of the rancho were Mills, having 22,240.44 acres, and Edwards, who took on 20,790 acres. By 1874, Cutler Arnold, James Hammell, Samuel Hill, Joseph Howard, C. E. Huse, and Olney Whiteside purchased approximately 4,000 acres each, with Howard picking up 8,416.

The Rancho period had two phases, the pre-drought and post-drought phases. Up until the drought years of 1876 and 1877, the Conejo was covered in vegetation, feeding thousands of roaming sheep and livestock. With several creeks and large oaks for shade, the Conejo Valley was a perfect landscape for grazing herds. E. P. Foster tended 2,000 sheep of his own and another 10,000 for Mills. E. S. Newbury's had 2,500 sheep, J. K. Sexton had 1,700, and the Arnolds had several thousand, as did Whiteside. Others leasing land for grazing included Thomas Bard. Estimated sheep before the drought was near 20,000. By the drought's end, a few thousand emaciated sheep worth 10¢ a head remained. The large landowners sold their acreage. Both Mills and Foster lost everything. Mills moved Los Angles, where he was able to rebuild his fortune. Foster walked to Ventura from the Conejo, sent a wagon for his family, then dug ditches before rebuilding his fortune.

In the post-drought years, ranchers were more cautious about herding livestock and more conscious of adapting to the land, with dry farming crops. New to the Conejo in these next years were Borchard, Crowley, Friedrich, Haigh, Hays, Hunt, Kelley, Russell, Wadleigh and the Norwegian Colony.

The Norwegian Colony started in 1890 when four families purchased four tracts in the northern portion of the Conejo. They wanted to buy land on the Colonia Rancho, but the price per acre was three times that of the Conejo land. The Hansen, Olsen, and Pederson families, plus O. Anderson, picked up 650 acres of dry, uncultivated, and challenging landscape to start new lives. The families chose parcels by draw; each lot was long and narrow, with the smallest lot measuring 97 acres and the largest 130 acres, though a fourth of it included a deep ravine, unsalvageable for farming. The Norwegians met with varying success and some tragedy. However, their ancestors have passed on a legacy of good memories and a lifetime of learning from the donation of the land for California Lutheran University by the Pederson family.

Schools in the area were as few as was the population. The first school was established on the Joseph Howard ranch in what is now Hidden Valley. Howard hired a young neighbor, a Miss Anderson, to teach his children in his home in 1876. The next year a 9-by-18-foot school was built in 1877 on land donated by Howard. This became the Conejo School. The Timber School was completed in 1889, and the Grand Hotel was used while the building was being constructed.

Water in Conejo was scarce but not absent. Besides the Triunfo Creek, the Salto Canyon had a waterfall and creek, known as Salto Canyon, or "jump" canyon, perhaps because the early inhabitants could not resist jumping in when they visited the site. In 1889, the Banning Company built a dam in the canyon of the Howard Ranch that had been purchased the previous year. The dam is thought to be the first and oldest concrete arch dam in California. By 1905, Fred Matthiessen completed his 184-acre lake, later named Lake Sherwood to commemorate the filming of the movie *Robin Hood*. The third man-made lake is the 150-acre Westlake Lake in Westlake Village.

This volume does not attempt to cover the complete history of any portion of the valley's past. However, these photographs offer a flavor of the early days.

One

PIONEERS

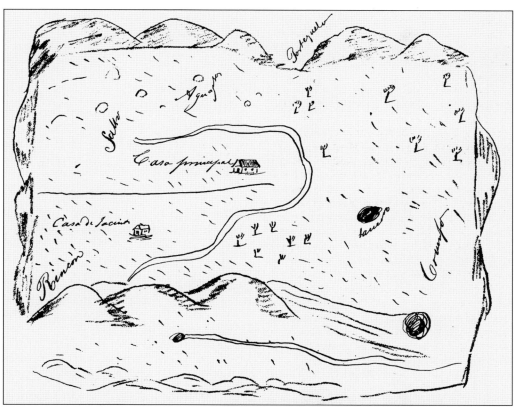

This image shows the *deseño*, or land grant map, of the area known as Salto de Conejo for Maria del Carmen Lorenzana. Lorenzana was the sister of Jose de Jesus Rodriquez and daughter of original Spanish land grantee Jose Ignacio Rodriquez. Lorenzana moved onto the Conejo property in 1833 with her husband, Jacinto Lorenzana, and two children. They lived in an adobe in the area known as El Rincon. It has been speculated that the adobe was located on what became the Janss Ranch near the shopping center.

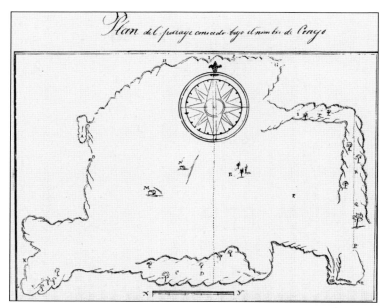

In 1822, soon after Mexico's reign of California began, Jose de La Guerra, who principally lived in Santa Barbara, petitioned for a re-grant of half of El Conejo Rancho. He claimed that original grantee Jose Polanco had abandoned his claim. De La Guerra was granted the El Triunfo portion, today's Westlake and North Ranch areas.

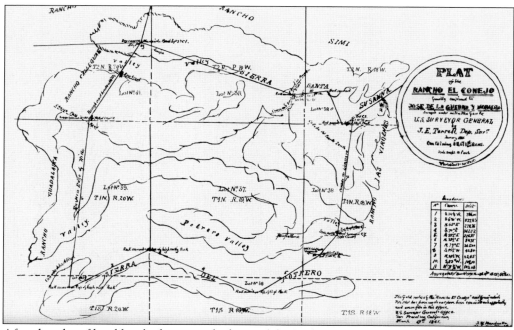

After decades of legal battles between the heirs of the Rodriquez and de La Guerra families, the U.S. Surveyor Generals office completed an official map of Rancho El Conejo. The total acreage of the grant was 48,671.56 acres.

Andrew Russell poses in front of the remnants of the de La Guerra adobe that was located on his ranch. Russell and his brother Hannibal Russell purchased 5,960 acres from Howard Mills in October 1881 for $15,000. (Courtesy Thousand Oaks Library, accession number LHP00393.)

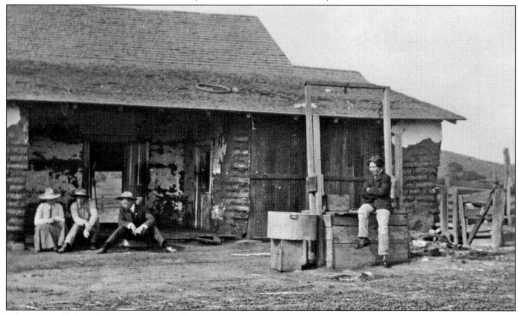

The Russell family originally used the adobe for their residence and later used it as a milk house. The de La Guerra adobe was ripe with rumors of hidden treasure buried under the house. Eventually gold seekers undermined the foundation of the structure by digging for gold and leaving the link to the Californio past to topple. (Courtesy Stagecoach Inn and Conejo Valley Historical Society.)

Howard K. Mills and his wife, Carolyn Freeman, along with their three children, came to California in 1870. Mills came to California upon advice from his doctor to move to an area with a warmer climate than the harsh winters he endured in Minnesota. In August 1871, Mills and partner John Edwards, both from Santa Barbara, purchased 23,835.75 acres for $55,000, at approximately $2.30 an acre, from the heirs of the de La Guerra family. Mills and Edwards purchased 4,500 head of sheep but would lose most of their investment to the drought of 1876–1877.

John Edwards married Elizabeth Sexton, and they had four children, all born in Ione, California. The Edwards, Sexton, Foster, and Hill families all participated in the gold rush in 1849 and later moved to the Goleta area. Edwards built a home in Conejo but lived in Santa Barbara, where he ran a hardware store and became a prominent banker.

Egbert S. Newbury (1843–1880) purchased 2,200 acres in 1874 from his partners Mills and Edwards. His property was near old town Thousand Oaks and stretched toward Hidden Valley. Newbury was the area's first postmaster, starting in July 1875, and also served as the area's news correspondent to the Ventura paper. However, the drought of 1876–1877 put a financial strain on the family, and they moved to Michigan, where Egbert's sister lived with her husband, Gov. John Judson Bagley. Egbert's short life ended here in February 1880. (Courtesy Stagecoach Inn and Conejo Valley Historical Society.)

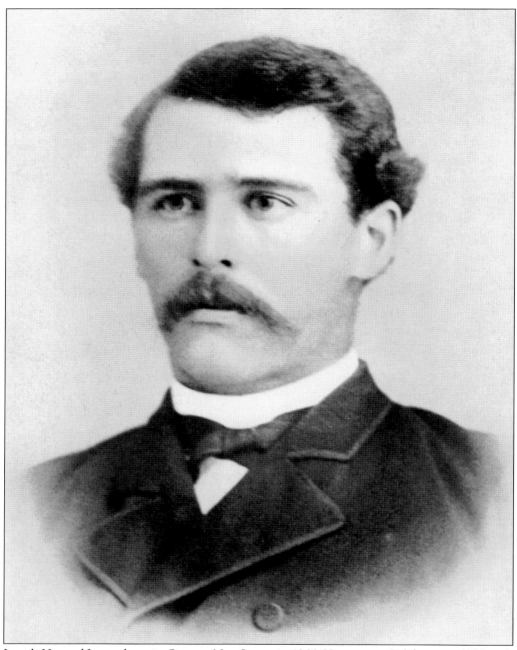

Joseph Howard Jr. was born in Orange, New Jersey, in 1866. He came to California in 1880 with his parents and lived in Santa Barbara. For a short time, he worked at his father's Conejo ranch, where he learned how to raise cattle, a skill he expanded upon and extended to other areas of the county and later in Arizona. Howard married Sarah Middleton, the daughter of Elizabeth Middleton, who was married to Samuel Hill.

Andrew Russell was born in Canada and moved to California in the 1870s, where he raised 1,200 head of sheep at a time in Santa Barbara county. While riding the stagecoach on his way to look at some grazing land in Conejo, Russell caught wind that his riding companion was traveling to Conejo for the same purpose. While stopping over in Ventura, Russell found the nearest livery stable and rented a horse to beat his competition to the real estate. Cutting through the countryside, Russell made it in time to take a 20-minute tour of the property, at which time he handed over a $20 gold piece to secure the sale just as the stagecoach arrived on the scene. (Courtesy Stagecoach Inn and Conejo Valley Historical Society.)

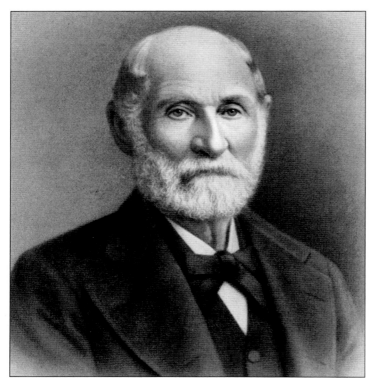

Samuel Hill was born in England and eventually made his way to the gold mines of Placerville in 1850. Hill married Sarah Middleton, the widow of Thomas Middleton. She had five children. Two of the young men, Thomas and Anthony Middleton, farmed several hundred acres from their stepfather. Hill was a neighbor of the Edwards brothers. Hill purchased 7,200 acres from Howard Mills in 1874 in the northern portion of the Conejo. He grazed his 12,000 sheep, but he lost all but 800 after the 1876–1877 drought and forfeiting 1,600 acres as compensation to the bank.

Greenbury Crowley was born in Missouri in 1830, and by 1861, he was farming in Visalia. After arriving in Conejo, Crowley persuaded his son Henry to leave his Norwalk ranch to join him in Conejo. Greenbury Crowley bought 2,259 acres in 1887 from Thomas Gormley, who purchased the property from the Bank of Ventura. The bank bought the foreclosed property from E. S. Newbury, who suffered through the drought of 1876–1877 with no crops and no sheep to graze the parched landscape.

Joseph "Joe" H. Russell was one of the four Russell brothers born to Andrew and Abigail Russell. His brothers included Merrill, Harvey, and Hub. Joe was born in 1883 at the Conejo Ranch. The family later renamed their property Triunfo Ranch to not confuse their ranch with the Janss Ranch. Russell's many adventures were captured in his two books, *Cattle on the Conejo* (1957) and *Heads and Tails . . . Odds and Ends* (1963). (Courtesy Stagecoach Inn and Conejo Valley Historical Society.)

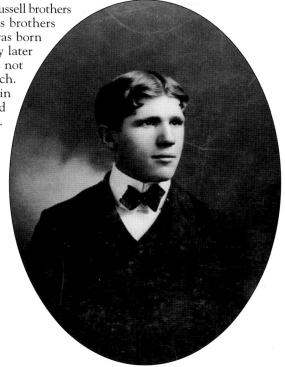

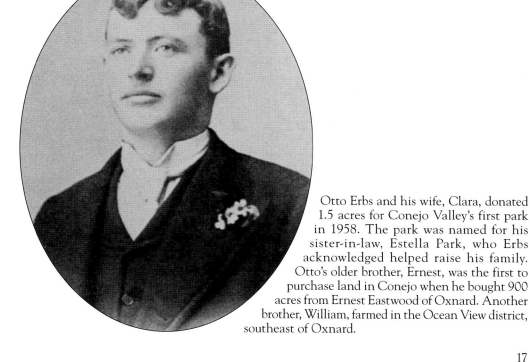

Otto Erbs and his wife, Clara, donated 1.5 acres for Conejo Valley's first park in 1958. The park was named for his sister-in-law, Estella Park, who Erbs acknowledged helped raise his family. Otto's older brother, Ernest, was the first to purchase land in Conejo when he bought 900 acres from Ernest Eastwood of Oxnard. Another brother, William, farmed in the Ocean View district, southeast of Oxnard.

Cutler Arnold and his sons purchased 5,500 acres from Howard Mills in 1876. Arnold was born in Ohio in 1818 and later moved to Illinois before traveling to California in 1849. Settling in Marysville, Arnold opened two stores to serve the miners. He married Smily Hough and raised six sons and two daughters. By 1869, Arnold had settled on what he thought was government land but later proved to belong to Thomas Scott. Of this land, 320 acres were purchased by Arnold and his sons. By 1879, Arnold grew 350 acres of wheat and 400 acres of barley, and raised 700 hogs. In 1881, he sold 3,300 acres to Johannes Borchard for $12,000.

Eugene Preston Foster came to the Conejo in 1876 and purchased 807 acres from John Edwards. Foster started with 10,000 sheep on the grassy lands of Conejo just as the two-year drought began to dry out the vegetation, which caused the reduction of his flock to 3,000 head of sheep. Foster walked to Ventura, sent a wagon back for his family, and took a job as a ditch tender for $40 a month. Hard work and perseverance led Foster to try his hand at growing apricots, which led to several real estate transactions and investments with the Bank of Ventura and the Union Oil Company. Foster became one of Ventura County's most generous benefactors with the donation of several parklands.

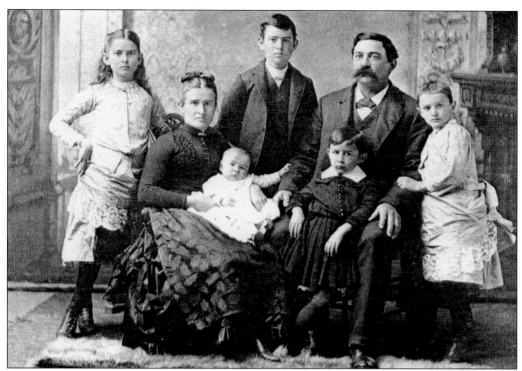

James Hebron Bell and Mary Rose Bell operated the Stagecoach Inn from 1894 to 1898. Their daughters Minnie and Lydia were married at the inn in 1897. Minnie married Andrew Cawelti, and Lydia married Herbert Fred Hunt. (Courtesy Stagecoach Inn and Conejo Valley Historical Society.)

Richard Orville Hunt purchased 954 acres of the Salto Ranch in 1876. He leased the ranch until 1888, at which time his large family came to live at the ranch. Hunt was a master blacksmith, skills he used to service the rugged wagons needed to navigate the rugged terrain of dusty roads in the Conejo. In 1891, Hunt was appointed postmaster, a position he held along with his wife, Mary Jane Hunt, until 1908. (Courtesy Stagecoach Inn and Conejo Valley Historical Society.)

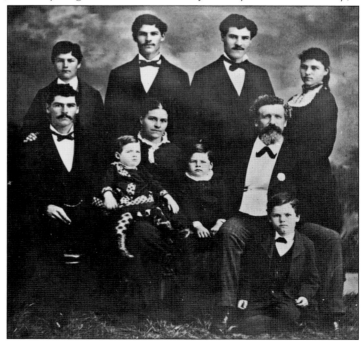

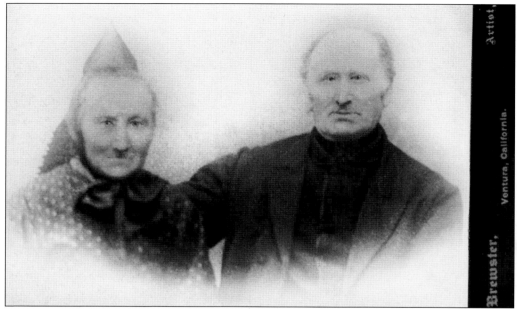

The J. C. Brewster photograph was created from a photograph taken in Germany of Caspar Anton Borchard and his wife, Elizabeth Huch, from Werxhausen, Germany. Caspar was the brother of Christian Borchard and the father of Caspar and Johannes Borchard. They never made it to California despite being featured on a cabinet card by Ventura's prominent photographer.

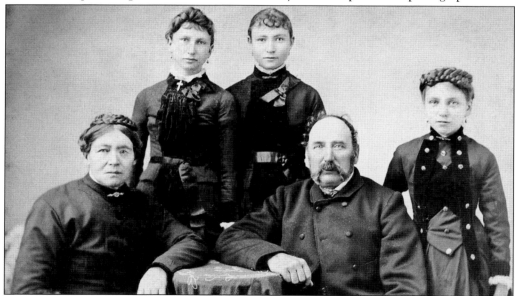

The Brewster photograph depicts the family of Johannes Borchard and his wife, Elizabeth Swedhelm. Standing from left to right are their daughters Annie Borchard (Friedrich), Mary Borchard (Fasshauer), and Theresa Borchard (Maulhardt). The two boys, ages nine months and six years, died on the long, treacherous voyage from Germany and around the southern tip of South America on to California. Borchard purchased 3,300 acres in Conejo from Cutler Arnold for $12,000 in 1881.

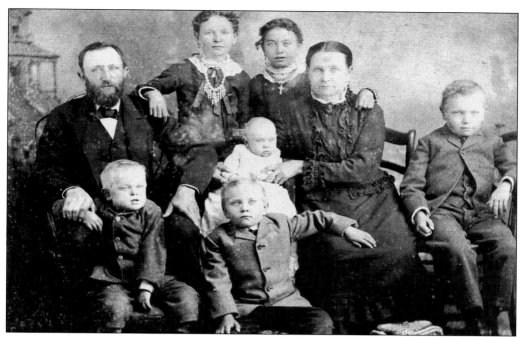

The Caspar Borchard family included, from left to right, (first row) Antone and Casper; (second row) Caspar, Frank (baby), Theresa Maring, and Leo; (third row) Mary and Rose. Caspar came to California in 1867 with the Maulhardts. He returned to Germany to collect his bride and some money to purchase land, and when he retuned, he purchased 200 acres of Rancho Colonia. By August 1882, Caspar had purchased 3,285 acres for $18,692 from Larkin Snodgrass, and he added several other parcels, totaling over 4,000 acres and giving the Borchard brothers more than 8,000 acres from present-day Highway 101 to Old Boney Mountain.

The Friedrich family arrived on the Conejo in 1882 and purchased 1,033 acres for $11,850. Pictured from left to right are Adolph, Franz, Emma, Joseph, Emma, Magdalena Huch, Ignatz, Emma, Mary, Herman, and Frank. Times were so tough the first few years that the family nearly returned to Germany. Fortunately a rainy season nourished their barley crop and gave rise to a new hope for the family. Soon the family began purchasing several tracts of land on the La Colonia to help diversify their crops selection and override the dry years.

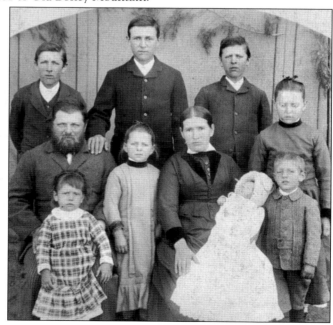

The Timber-Conejo School Districts map was published in 1912 by W. E. Alexander as part of his oversized book *Historical Atlas of Ventura County.*

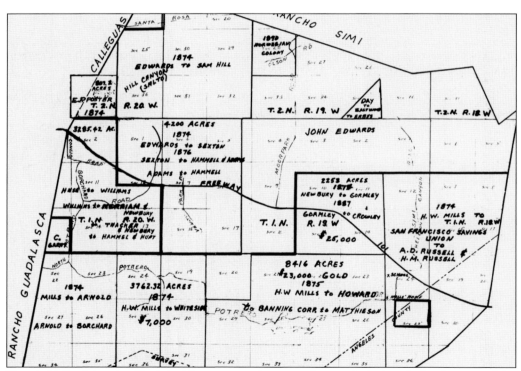

Conejo Valley historian Patricia Allen put together several maps depicting the landowners of the Conejo from 1874 to 1912. Map No. 1 shows the division for land between John Edwards, Howard Mills, and Egbert Newbury to the succeeding landowners. Edwards claimed the majority of the northern portion of the Conejo, and Mills claimed the southern sections, while Newbury owned a 2,253-acre section in the middle.

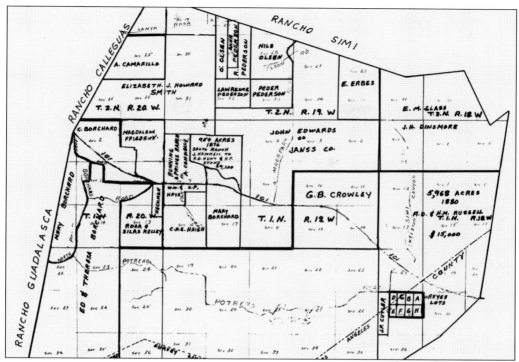

Map No. 2 shows more landholders with smaller parcels. Though this second map shows the time period between 1900 and 1930, not all landholders are listed.

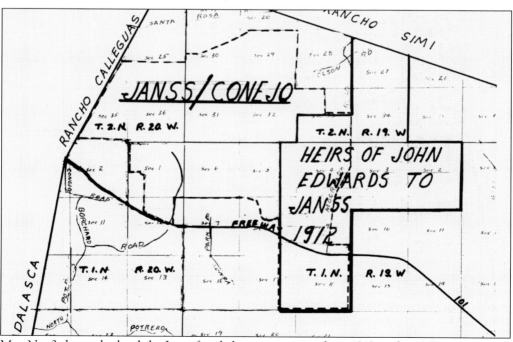

Map No. 3 shows the land the Janss family began acquiring from 1912 to the 1950s.

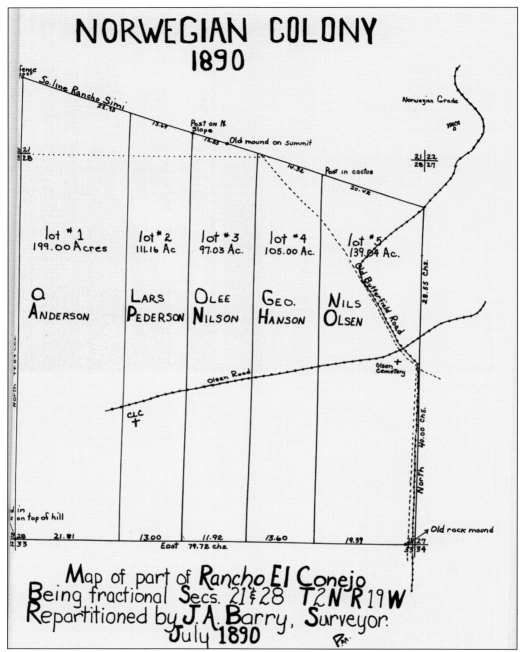

NORWEGIAN COLONY
1890

fence post

So. line Rancho Simi. 22.73

73.67

Post on N. Slope

12.23

Old mound on summit

14.32

Post in cactus

20.42

Norwegian Grade

YMCA

21 | 22
28 | 27

21
28

lot #1
199.00 Acres

O
ANDERSON

lot #2
111.16 Ac

LARS
PEDERSON

lot #3
97.03 Ac.

OLEE
NILSON

lot #4
105.00 Ac.

GEO.
HANSON

lot #5
139.04 Ac.

NILS
OLSEN

Old Butterfield Road

28.55 Chs.

North 77.97 Chs.

Olsen Road

Olsen
Cemetery

CLC

40.00 Chs.

North

in on top of hill

28
33

21.81

13.00

11.92

East 79.72 chs.

13.60

19.39

28 27
33 34

Old rock mound

Map of part of Rancho El Conejo
Being fractional Secs. 21 & 28 T2N R19W
Repartitioned by J.A. Barry, Surveyor.
July 1890

In 1886, five ambitious young men left Ura, Norway, and landed in Santa Barbara. They sought land on the Colonia Rancho, but at $10 an acre, the $2 per acre Conejo land was more affordable, even if barren. The Norwegian Colony was established in 1890 and was located west of Moorpark Road at the north end of Rancho El Conejo. Four families, the Pedersons, Neilsons, Hansens, and Olsens, as well as Ole Anderson, purchased 650 acres from the heirs of John Edwards, who they met while living in Santa Barbara. A portion of the Anderson land, and later the Pederson land, became the site of California Lutheran College.

The land divisions for the
Norwegian Colony were chosen
by drawing lot numbers out of
a hat. Ole Neilson received lot
No. 3, containing 97.03 acres.
Dry farming was hard enough
with little rain, but after several
years of virtually no rain, the
Neilsons left the Conejo for
the northern part of the state.
(Courtesy Stagecoach Inn and
Conejo Valley Historical Society.)

Nils Olsen owned lot No. 5
of the Norwegian Colony,
containing 139 acres. The
lot was also intersected by
the Old Butterfield Road
and later the Norwegian
grade. Cutting through the
middle of the lot is present-
day Olsen Road. Nils and his
wife, Ellen, raised 10 children,
with only three surviving to
adulthood. This led to the
Olsen cemetery. The Olsens
farmed the land productively
for 70 years, holding onto the
last 5 acres out of nostalgia,
but eventually selling it
to California Lutheran
University in the 1980s.

Karn Pederson and her three sons, from left to right, Lawrence, Peder, and Richard, are pictured here. Her husband, Lars Pederson, passed away from typhoid fever, prompting Karn to return to Santa Barbara to raise her four young children, the three sons and one daughter, Anna. Sons Peder and Richard relocated to Conejo first in 1913, with the rest of the family returning within two years. The Pedersons added 15,000 hens that laid 9,000 eggs a day.

Jorgon (George) Hansen and Lena Ness were married in Santa Barbara in 1891. Hansen drew lot No. 4, which was 105 acres between the Neilson and Olsen lots. In 1900, while driving his hay wagon, George fell victim to the steep drop from the Butterfield grade, and eventually, Lena returned to Norway with her daughter. (Courtesy Stagecoach Inn and Conejo Valley Historical Society.)

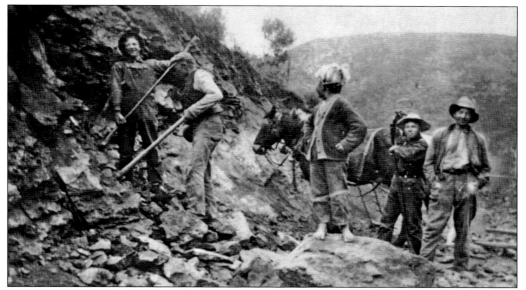

The Olsen family donated a portion of their ranch to help create a safer route from the steep and treacherous Butterfield grade that spilled out into the Moorpark area. Many residents were injured or died trying to travel the grade, including Jorgen Hansen, whose wagon plunged down the side of the road. The family spent two years carving out the new route, known as the Norwegian grade, and a total of 10 years was needed to complete the new, safer road. (Courtesy Stagecoach Inn and Conejo Valley Historical Society.)

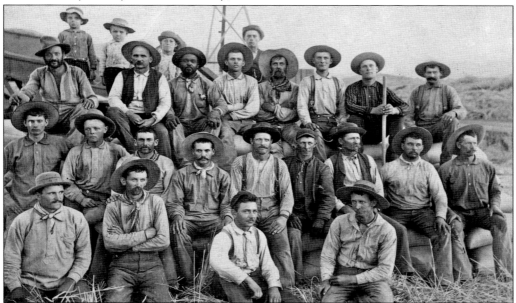

Orville Austin Wadleigh rented between 6,400 acres and 14,000 acres from the heirs of John Edwards for 40 years. His home was located near the Thousand Oaks City Hall, where he also had a dairy with 125 cows, 150 hogs, and hundreds of poultry. In addition to needing men to work his dairy, Wadleigh needed a large crew to thresh his grain and was most likely the largest employer of the early Conejo. (Courtesy Stagecoach Inn and Conejo Valley Historical Society.)

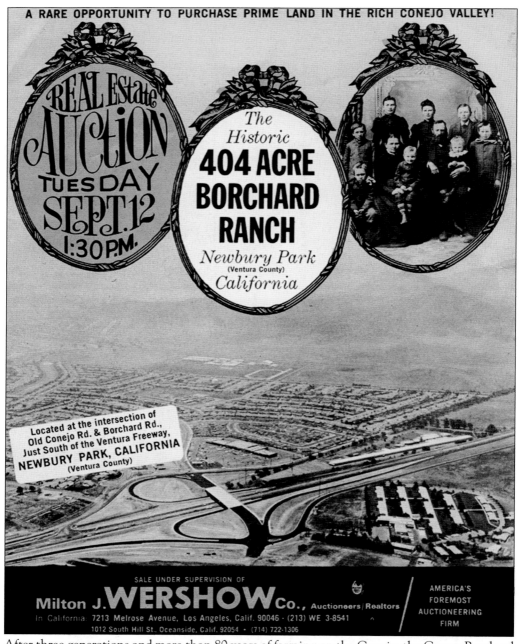

After three generations and more than 80 years of farming on the Conejo, the Caspar Borchard heirs became too boxed in by suburbia to continue the family's tradition. The Janss Corporation and the Chacksfield Merit Homes Corporation purchased the last 404 acres of the Newbury Park ranch. The homes built were part of the Dutch Haven tract. When opened to the public, the 380 homes sold in nine months, with prices ranging between $19,000 and $23,000.

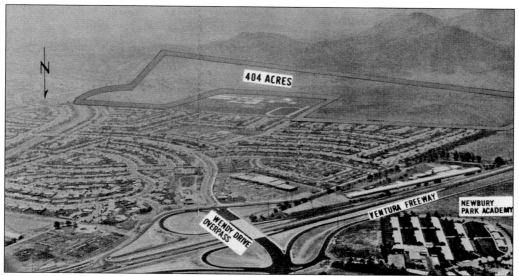

The 404 acres were situated between the base of the western mountains to Jenny Drive on the east, from the Old Conejo Road on the north to the south, to Borchard Road on the east.

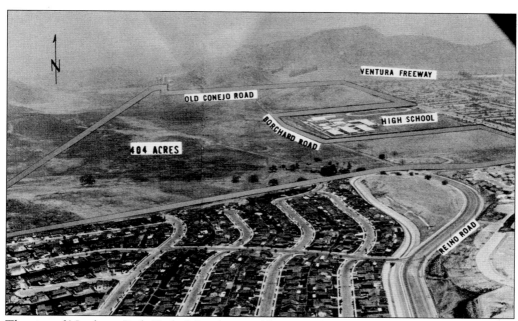

The site of Newbury Park High School was sold previously, as were portions to the east and south. However, the Borchard family did not give up on farming. Taking the proceeds from the sale of the land, Robert and Allen Borchard bought ranching properties in Winters and Woodland near Sacramento. Ed Borchard Jr. purchased land in Salinas and helped pioneer the artichoke industry.

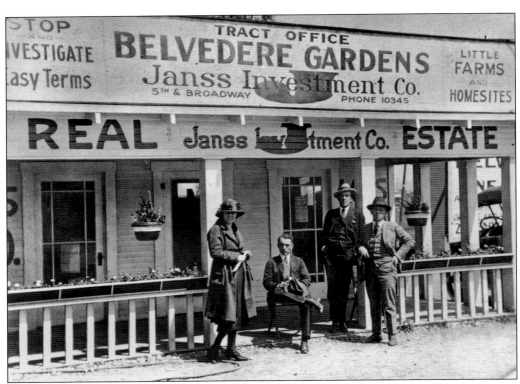

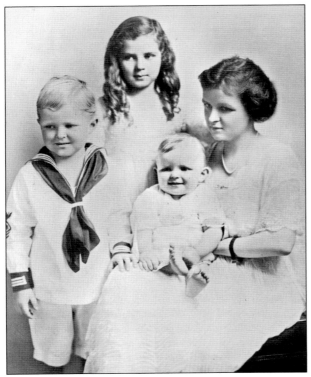

Dr. Peter Janss arrived in Los Angeles in 1893. Soon after, he opened a small real estate office that made some big purchases. His sons, Edwin and Harold, took over the business in 1906. In 1910, the Janss Corporation purchased 6,000 acres of Conejo property from the heirs of John Edwards. The Conejo Ranch soon grew to 10,000 acres stretching from Lawrence Drive to Erbs Road from the ridgeline on the south to below the Norwegian grade on the north.

Florence Janss poses with her children, from left to right, Edwin Jr., Patricia, and William. The Janss sons would take on their father's corporation and come up with the master plan for Thousand Oaks.

Two

Homes, Barns, and Farms

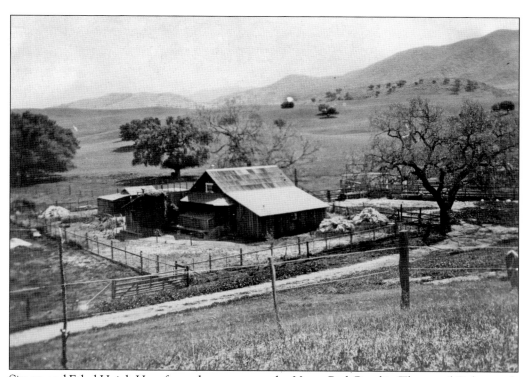

Simon and Ethel Haigh Hays farmed near present-day Ventu Park Road in Thousand Oaks, south of the Ruining Springs Ranch and north of the Cecil Haigh Ranch. They raised two children, Reba and H. Allen Hays. (Courtesy Stagecoach Inn and Conejo Valley Historical Society.)

The R. O. Hunt ranch included a little of everything. Because the ranch had access to one of the few creeks in the area, the land could grow orchards of apricots, peaches, apples, nuts, and olives. The Hunt family raised seven boys and one girl, who all helped with the chores of running a large spread. They had a creamery where the family churned more than 100 pounds of butter a week. (Courtesy Stagecoach Inn and Conejo Valley Historical Society.)

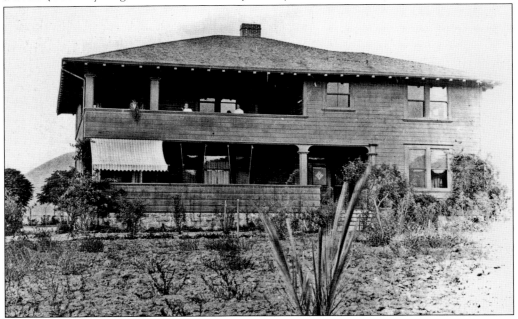

The Hunt home was located near the cul-de-sac at the south end of Calle Yucca, Thousand Oaks. Built around 1900, the home burned down in 1946. (Courtesy Thousand Oaks Library, accession number LHP00513.)

After decades of farming the 950 acres, the family sold the west end of the ranch in 1918 to the Lynn family, and later this land was developed by the Janss Corporation and marketed as estate lots. The remaining portion was divided among the heirs, and the last parcel was sold in 1968 by Richard E. Hunt, the great grandson of R. O. Hunt. (Courtesy Stagecoach Inn and Conejo Valley Historical Society.)

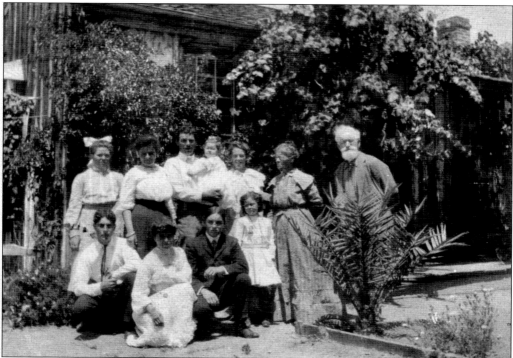

The Salto Ranch, as the Hunt Ranch was referred to, was also the site of a petrified tree, estimated to be 20 million years old. A small portion was removed to the ranch of William Hunt, and the remaining trunk was buried under the Tierra Grande section of the Lynn Ranch. (Courtesy Stagecoach Inn and Conejo Valley Historical Society.)

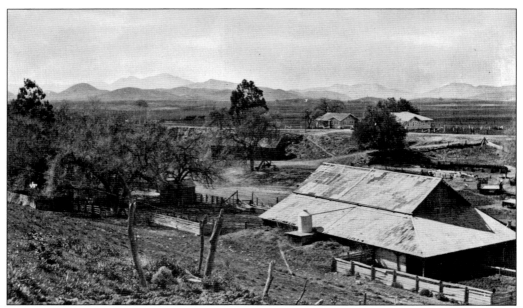

Otto and Clara Erbes farmed 30 acres in the middle of the valley, which they purchased from the Janss family in 1940. The Erbes later donated the land for Thousand Oaks' first public park. Otto's brother Ernest purchased a larger section of land from Ernest Eastwood in 1909. He farmed in Simi Valley as well as Moorpark. (Courtesy Stagecoach Inn and Conejo Valley Historical Society.)

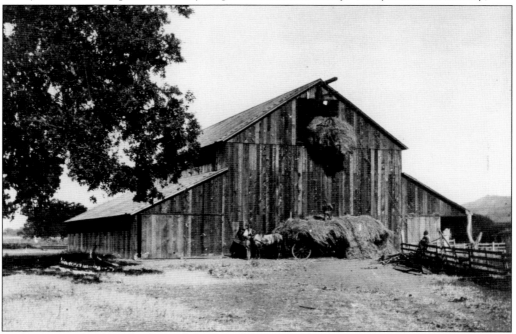

In the spring of 1908, a fire burned the Russell home and barn to the ground in 45 minutes. The Russells immediately built a new barn and ranch home. The ranch served as the background for many motion pictures including *State Fair* (1945) and *The Lash* (1930), as well as the landscape for many celluloid cattle drives. (Courtesy Stagecoach Inn and Conejo Valley Historical Society.)

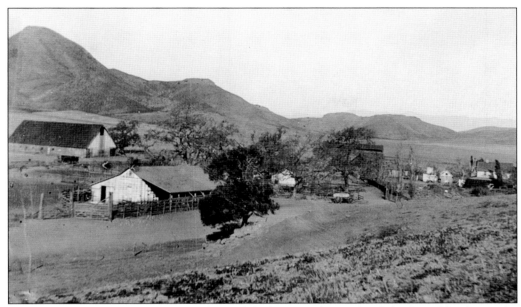

Here is a view of the Caspar Borchard Ranch looking north. Borchard also leased land near the town of Hueneme as a holding lot for his livestock. Borchard began farming on the Oxnard Plain in the late 1860s and again in the 1870s. He purchased his first tract of land in Conejo in August 1882, measuring 3,285 acres for $18,882 from Larkin Snodgrass. He purchased several more tracks of land, including 170 acres from James and Martha Hammell in October 1882.

The Janss Ranch originally grew lima beans, grain crops, and apricots; they later added cattle and finally 300 thoroughbred horses. The ranch was also the location site for many *Bonanza* television episodes from the late 1950s through 1970, as well as home to dozens of other television series and motion pictures. (Courtesy Stagecoach Inn and Conejo Valley Historical Society.)

By the time of his passing in 1930, Caspar Borchard had welcomed more than 30 grandchildren to his Conejo ranch. As the family grew, his children branched out to other portions of the state and farmed in Orange County and the Imperial Valley.

The Albertson Russell ranch eventually grew into the community of Westlake Village. While the Russell family continued ranching cattle after the sale to William Randolph Hearst in 1925, and later to Fred Albertson in 1943, the area became a favorite location for many Hollywood movies, including *Robin Hood*, *King Rat*, *Laredo*, and *Tarzan*. (Courtesy Stagecoach Inn and Conejo Valley Historical Society.)

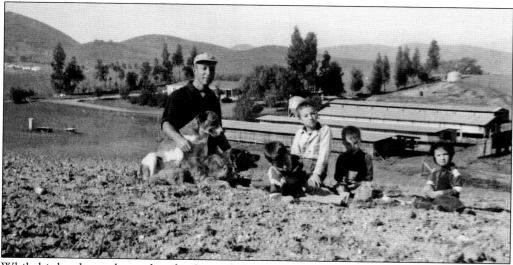

While his brothers relocated to the Oxnard Plain to farm their other ranches, Adolph Friedrich continued working the home ranch, located west of the Running Springs Ranch and north of the current Highway 101. The 1,000-acre ranch was sold in 1962 to the Janss Investment Corporation and became the Rancho Conejo Industrial Park. The children pictured are, from left to right, Edwin, Michael, Thomas, and Mary. (Courtesy Stagecoach Inn and Conejo Valley Historical Society.)

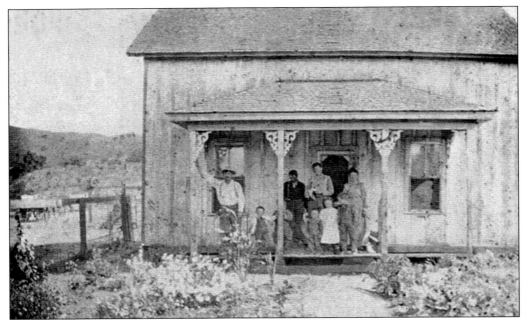

Silas Kelley came to California with his father and siblings after his mother passed away in Nebraska in 1890. His father, John Kelley, purchased 100 acres from Caspar Borchard near present-day Michael Street and Borchard Road. In 1899, Silas married Caspar's oldest daughter, Rosa. The Kelley's later added 551 acres from Rosa's family.

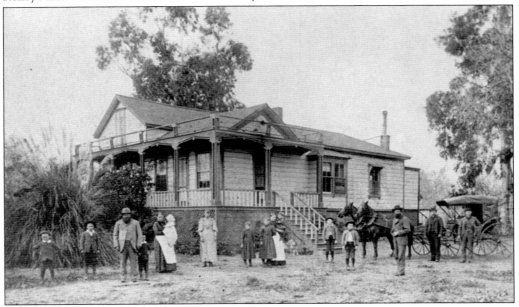

The Franz Joseph and Magdalena Friedrich family began farming on the Conejo in 1882 and continued for the next 80 years. Eventually the family purchased several ranches on the Rancho Colonia, and they were instrumental in contributing to the development of Catholic education in Oxnard. They raised nine children, who married into the Borchard, Kellner, Kohler, Brucker, and Munzy families.

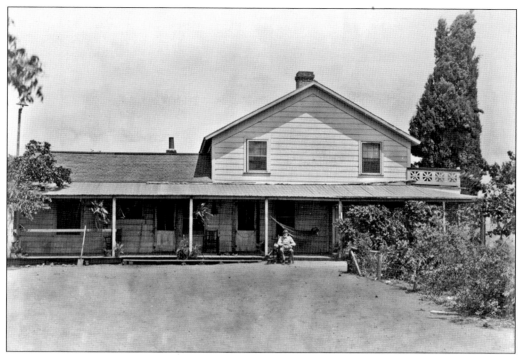

The home of Caspar Borchard served to raise eight children, including Rosa, Mary, Leo, Casper, Antone, Frank, Charles, and Teresa. Their mother passed away in 1898, and daughter Mary took over the reigns of raising her younger siblings as well as caring for her father until his passing in 1930.

The Crowley House was built in 1910 for Frank and Mae Crowley. The home later served as a real estate office for the community that became Thousand Oaks. The house is currently owned by the Conejo Recreation and Park District and is Historical Landmark No. 7 in Thousand Oaks.

The Conejo Open Space Conservation Agency was created in 1977 in conjunction with the City of Thousand Oaks and the Conejo Recreation and Parks District to preserve and protect land resources in Conejo Valley. Rancho Sierra Vista is one of the areas that is protected, including a hay barn built by Carl Beal in Sycamore Canyon. Beal purchased the land from the descendants of Johannes Borchard.

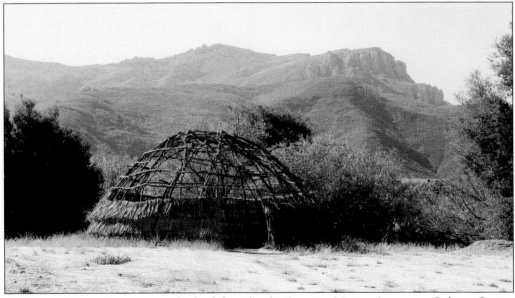

Old Boney Mountain serves as the backdrop for the Satwiwa Native American Culture Center at Rancho Sierra Vista. *Satwiwa* means "bluffs" and refers to a former Chumash village. This area was part of the trade route for the early native Chumash as they traveled between the coast and the valleys of Conejo.

Three

THE LANDSCAPE

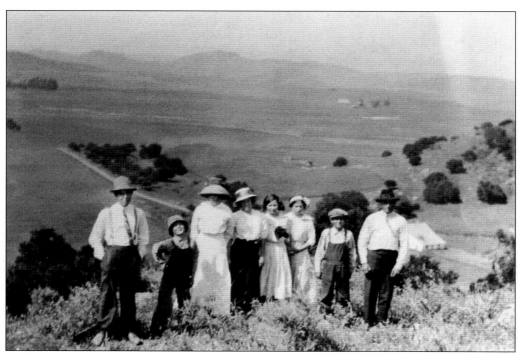

The Kelley family poses near their 700-acre ranch, which was located next to the Caspar Borchard Ranch on the west and Haigh Ranch to the east and south of the old Conejo Road. Silas Kelley married Rosa Borchard in 1899 and raised eight children, Charles, John and Teresa (twins), Walter, Fred, Rose, Dorothy, and Josephine. (Courtesy Stagecoach Inn and Conejo Valley Historical Society.)

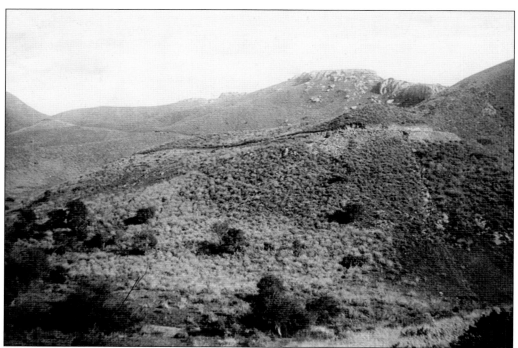

Old Boney Mountain can be seen in the background of this photograph, taken near the Borchard Ranch around 1910. The Southern Pacific Railroad used the Old Boney Mountain site to quarry rocks for the building of the railroad through the Camarillo area in 1901.

Tarantula Hill, pictured in the distance with oak-studded vistas in the foreground, is a part of the Conejo Valley regional parks holdings. (Courtesy Thousand Oaks Library, Call # 01-12-1967/1.)

Joseph Howard was born in Connecticut and came to California in the 1870s to Santa Barbara. In 1875, he purchased 8,476 aces for $23,000 from Howard Mills. One of Howard's acquaintances from his East Coast days was Samuel Clemens, otherwise known as the writer Mark Twain. He is said to have visited the ranch on two occasions. The community of Westlake makes up the majority of Howard's former ranch. (Courtesy Thousand Oaks Library, accession number LHP00506.)

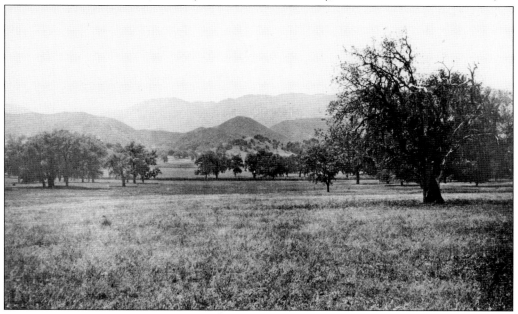

Howard's home served as the site for the first church services sometime after 1876. Howard's daughter, Mary, married Henry Stebbins in 1875, making their union the first wedding on the Conejo. Howard maintained a home in Santa Barbara, where he served on the board of the First National Bank. He sold his Conejo holdings in 1888 to the Banning Company, out of Long Beach. (Courtesy Thousand Oaks Library, accession number LHP00505.)

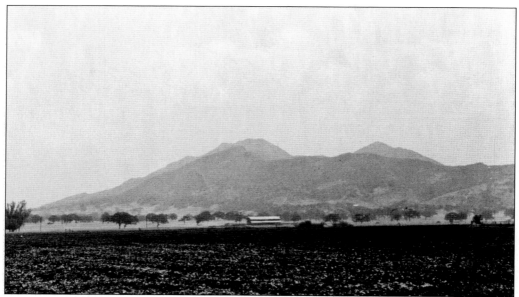

The Russell Ranch was sold to William Randolph Hearst in 1925. Hearst owned the Southern California Land Company, and the company immediately began drilling for oil. The Russells continued to lease the land from Hearst. By 1943, the company had given up looking for oil and had sold the land to B. B. Albertson, the West Coast representative for the Oldsmobile Company. (Courtesy Stagecoach Inn and Conejo Valley Historical Society.)

In 1875, Henry Stebbins married Mary, the daughter of Joseph Howard, marking the first wedding on the Conejo. Stebbins visited the Conejo as early as 1873, when John Edwards offered Stebbins 300 acres of grazing land. He ended up with 70 acres that he used for barley cultivation and 50 acres rented from his father-in-law for wheat. His livestock included 20 horses, 25 cattle, and 120 hogs. Stebbins claimed to have shot 350 deer in the first 14 years in Conejo. The Stebbins built a home near the Howard home. (Courtesy Stagecoach Inn and Conejo Valley Historical Society.)

The Hunt Ranch included two homes, a bunkhouse, two barns, a silo, a creamery, a tack room, a blacksmith shop, and a windmill. The Hunt Ranch was located near the Thousand Oaks Los Robles golf course. (Courtesy Thousand Oaks Library, accession number LHP00517.)

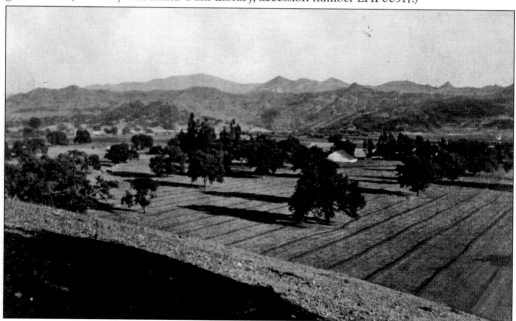

When the Russell brothers purchased the 6,000 acres in 1880, the ranch was called the Triunfo Ranch. Later it was called the Conejo Ranch, but after the Janss family referred to their ranch as the Conejo Ranch, the Russell family went with the Russell Ranch. After the Albertsons purchased the ranch in 1943, it was called the Russell Albertson Ranch. (Courtesy Stagecoach Inn and Conejo Valley Historical Society.)

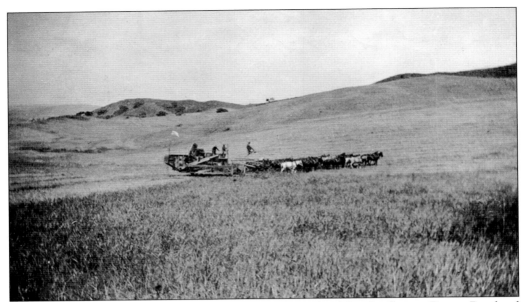

The four pictures on these pages come from several Borchard family albums. Caspar Borchard had five sons, Leo, Casper Jr., Antone, Frank, and Charles. All five boys worked for their father, but one by one, they branched out on their own to farm.

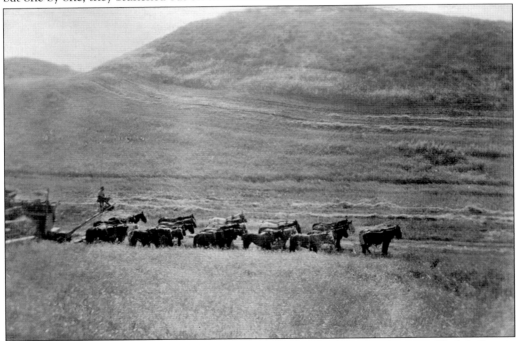

Leo Borchard, born in 1876 and the oldest, was the first to strike out on his own. He left Conejo in 1898 and helped reclaim the area in Orange County known as Talbert and later Fountain Valley. Using a ditch-digging machine owned by his father and some partners, Leo drained 30,000 acres of marshland, creating fertile farmland to make Orange County one of the state's leaders in agriculture.

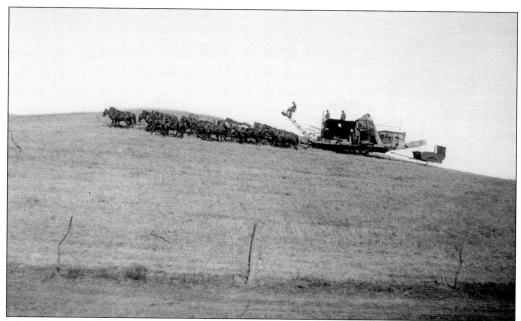

This photograph is labeled Wendy Drive. Antone Borchard farmed the Conejo until 1913, at which time he and his siblings purchased a 245-acre ranch from Ed Farnsworth in the area of Greenville. The next year, the Borchard siblings formed the Borchard Land Company and pooled their earnings into several more ranches in Southern California.

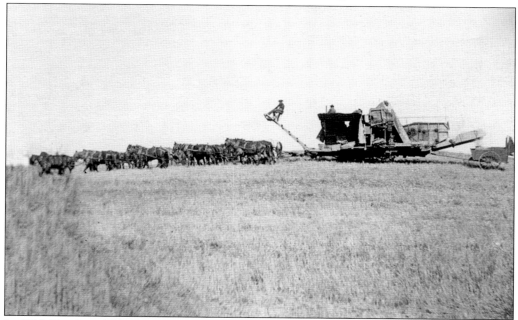

In 1908, Frank and Charles Borchard moved to Huntington Beach to begin farming. Soon they joined Leo in leasing more than 1,000 acres in Orange County. While Casper Jr. joined his siblings in forming the Borchard Land Company, he also continued farming the Conejo property for several more decades.

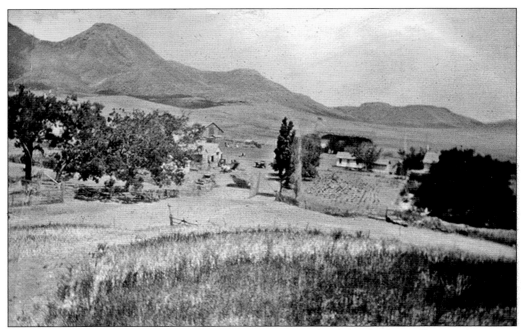

Pictured are four more photographs taken from various Borchard family photo albums. The images show the west end of the Conejo Valley. This view of the Conejo shows the western mountain ranch toward the Caspar Borchard Ranch.

Here is a view of the Conejo Valley taken from the west end and looking east over the Caspar Borchard, Silas Kelly, and Ed Borchard ranches around 1920. (Courtesy Stagecoach Inn and Conejo Valley Historical Society.)

Ed Borchard is seen here with daughter Margaret near one of the many hills on the western edge of the Conejo after a recent harvesting.

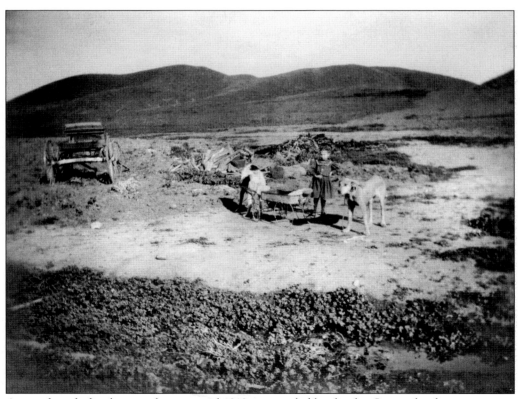

An unidentified girl is seen here around 1910 surrounded by the dry Conejo landscape.

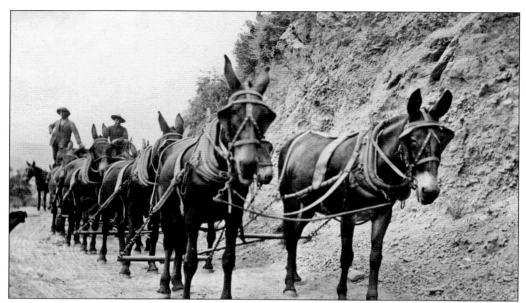

A mule team is driven by Louis Maulhardt, Andrew Lorenzana, and Ed Rogers as they navigate the Lewis grade, or the long grade. The Lewis grade was the entryway for the Conejo farmers to take their harvest to the wharf in Wynema (Hueneme) before the railroad was established in 1902 in Camarillo.

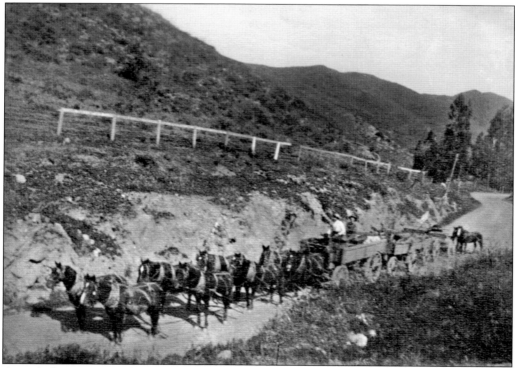

An eight-horse team with four empty hay wagons makes its way up the Lewis grade after returning from the Oxnard Plain.

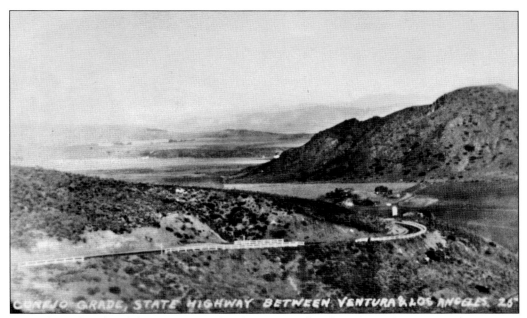

Once the railroad and depot was completed in Camarillo, the Conejo farmers put their money together to establish the "short grade," the Conejo grade. Until this time, farmers had to lock the wheels of the wagon with a chain or tie a big tree limb behind the ring and slide down to the bottom of the grade. Most preferred the long grade to the steep slide that became the Conejo grade. (Courtesy Stagecoach Inn and Conejo Valley Historical Society.)

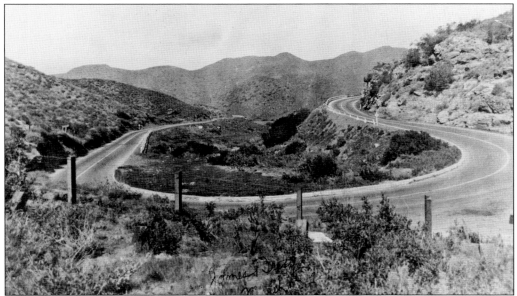

It took until 1937 before the Conejo grade would straighten out enough to eliminate horseshoe bend, seen here in 1924. Another obstacle was a huge boulder, which was later eliminated. The original 5.6-mile road with 49 sharp turns and cut backs was smoothed out to 12 long miles with wide curves to connect Conejo Valley and the Old Conejo Road in Camarillo. (Courtesy Stagecoach Inn and Conejo Valley Historical Society.)

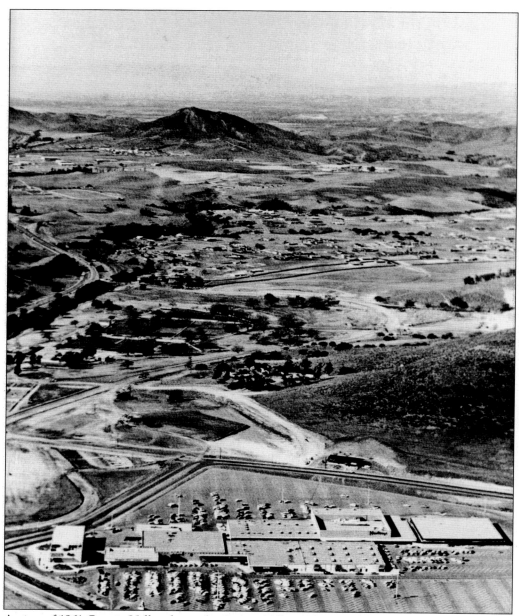

A view of 1961 Conejo Valley shows the Conejo Village Shopping Center.

This aerial view is of the Lynn Ranch before the start of development in the area around 1958. The community was part of a five-year master plan by the Janss Investment Company. (Courtesy Thousand Oaks Library, accession number LHP00353.)

This aerial view of Thousand Oaks and Newbury Park shows a view to the west. (Courtesy Thousand Oaks Library, accession number LHP02716.)

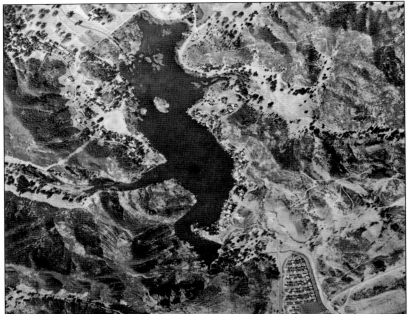

This aerial photograph of Lake Sherwood shows how the man-made lake sits within the mountains of Hidden Valley. (Courtesy Thousand Oaks Library, accession number LHP3623.)

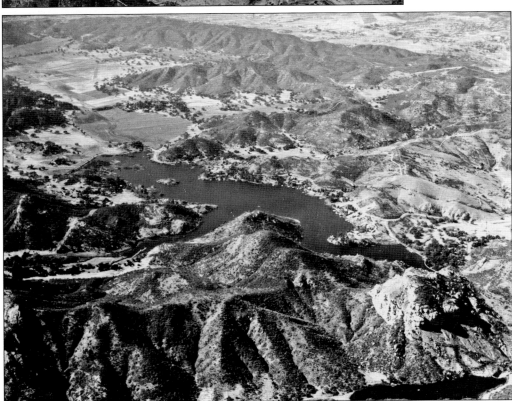

Here is a broader view of Lake Sherwood showing Thousand Oaks to the north. (Courtesy Thousand Oaks Library, accession number LHP03674.)

The American-Hawaiian Steamship Company partnered with Prudential Insurance Company and purchased 12,000 acres for $32 million from the Albertson Estate for the purpose of creating "city in the country," which became Westlake Village. Two-thirds (8,544 acres) of Westlake Village was located in Ventura County, while the remaining 3,456 acres fell within Los Angeles County. (Courtesy Thousand Oaks Library, Accession number LHP03706a.)

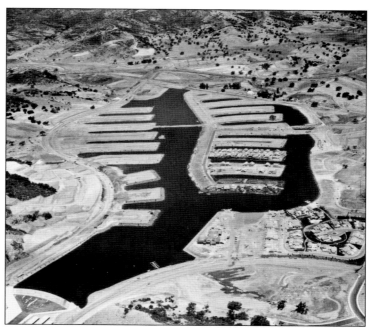

The Westlake Lake was created on 150 acres of land with docking privileges for private and commercial purposes. Over the years, the lake has been stocked with bass, blue gill, and catfish. Annual boat races are held every Fourth of July. (Courtesy Thousand Oaks Library, accession number LHP03706a.)

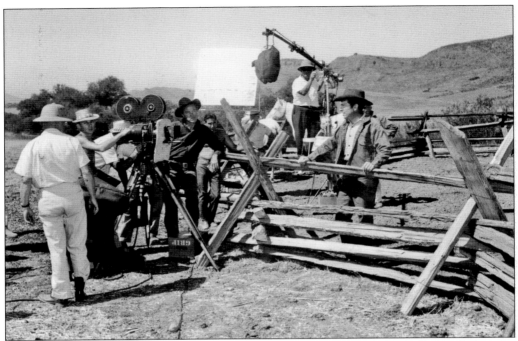

Hundreds of movies and television shows have been filmed in the Conejo Valley, including the scene that is about to be shot in the Wildwood Park area for the television program *Gunsmoke*, which ran from 1955 to 1975. (Courtesy Stagecoach Inn and Conejo Valley Historical Society.)

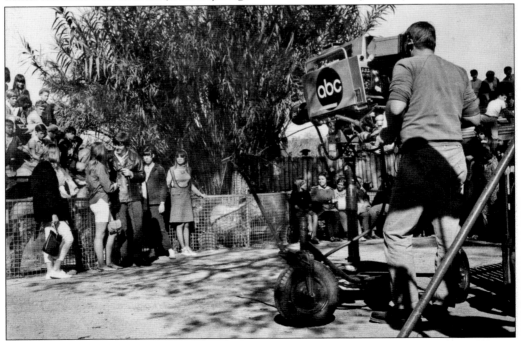

Dick Clark's *Where the Action Is* was filmed at Jungleland with teen idol Keith Allison singing to young valley girls from Conejo.

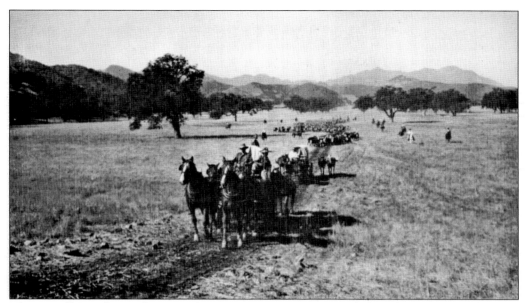

The Russell Ranch was the scene for many Western movies, including the 1930 film *The Lash*, starring Richard Barthelmess and Mary Astor, and set in 1848 California. For their cooperation with filmmakers and for their small roles in the film, the Russell family was invited to Hollywood for the grand premiere. The movie *State Fair* was another Russell Ranch location film.

This view of Moorpark Road was taken around 1960. (Courtesy Stagecoach Inn and Conejo Valley Historical Society.)

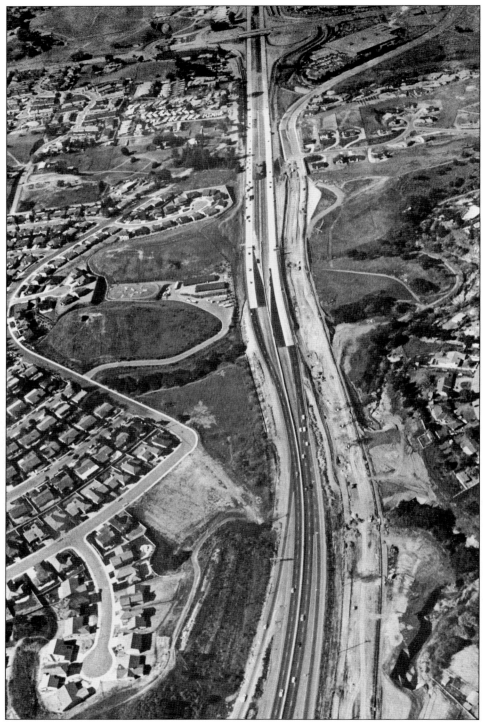

This is a 1982 view of Hillcrest Drive from Thousand Oaks to Newbury Park, winding through Lynn Road to Ventu Park Road. (Courtesy Thousand Oaks Library, accession number 2-921982/5.)

Four

LAKES, STREAMS, AND DAMS

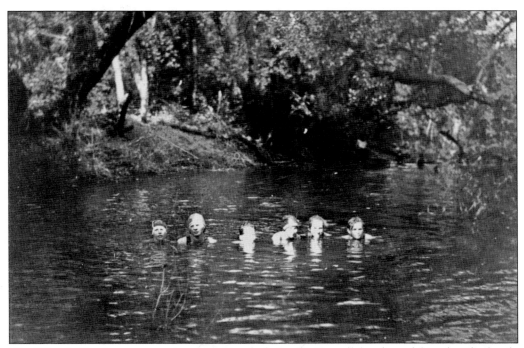

The Triunfo Creek was a popular swimming hole for the Russell family and friends. The battle of Triunfo was fought between the Spanish and the Native Americans near the creek, and thus, the Spanish named the area in honor of their triumph. (Courtesy Stagecoach Inn and Conejo Valley Historical Society.)

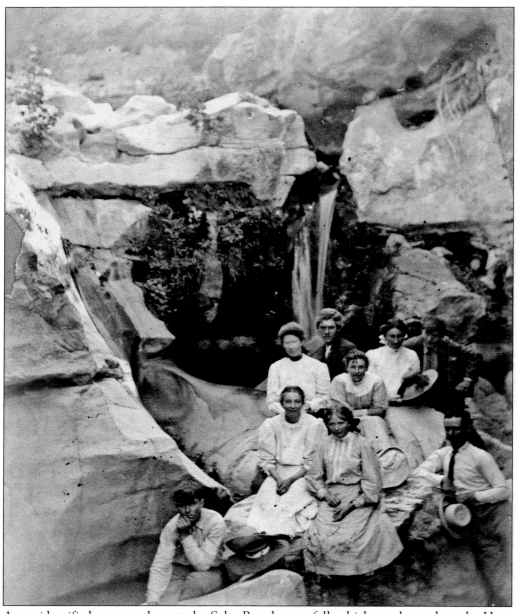

An unidentified group gathers at the Salto Ranch waterfall, which was located on the Hunt Ranch. (Courtesy Thousand Oaks Library, accession number LHT00410.)

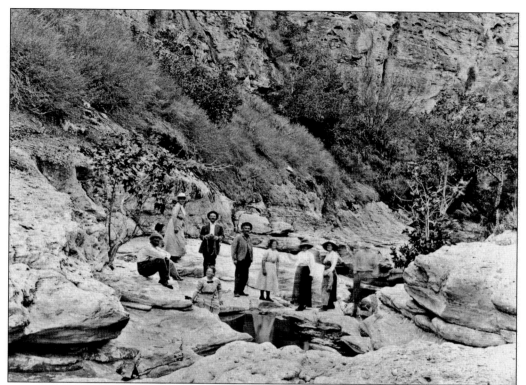

The Salto Ranch was named for the deep ravine and creek, and was the southwest border of the ranch. *Salto* is the Spanish word for jump, dive, or leap. *Salto de agua* is a waterfall. Since the *agua* (water) was scarce during the drought years, the Salto name remained, but the *agua* vanished. (Courtesy Stagecoach Inn and Conejo Valley Historical Society.)

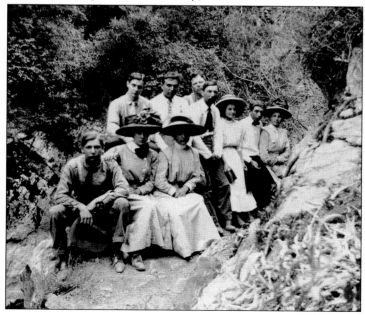

The Friedrich family farmed on land to the west of Salto Canyon, and they were frequent visitors to the creek.

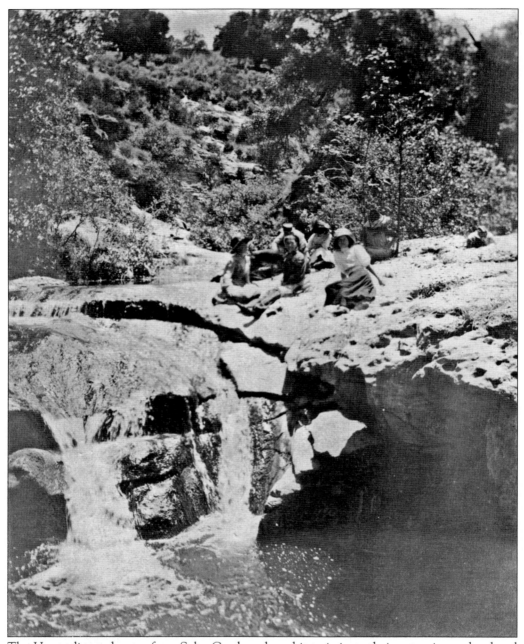

The Hunts diverted water from Salto Creek and used it to irrigate their extensive orchard and gardens. Today the water source is called Conejo Creek. (Courtesy Stagecoach Inn and Conejo Valley Historical Society.)

While the majority of the early photographs taken at Salto Creek are unidentified, there is a good chance that they are of the Hunt family and friends, and were taken by someone's Brownie camera, which were first sold to the public in 1900 for $1. The 1900 advertisements proclaimed that the cameras could be "operated by any school boy or girl." (Courtesy Stagecoach Inn and Conejo Valley Historical Society.)

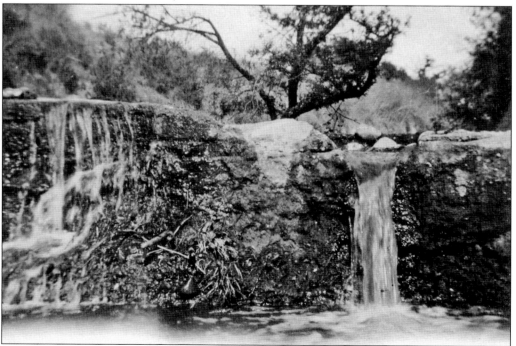

The Salto waterfall flowed year-round most years, except for the successive drought years. (Courtesy Stagecoach Inn and Conejo Valley Historical Society.)

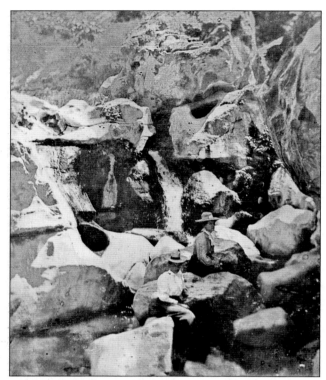

The Conejo Recreation and Parks District acquired the Wildwood Canyon and the Mount Clef Ridge from the Janss Corporation in 1967. The Wildwood Mesa was added in 1987, and the park includes 1,765 acres and falls under the jurisdiction of the Conejo Open Space Conservation Agency.

The Wildwood Park includes a variety of plant and animal species, including 37 species of birds, 37 mammals, and 22 reptiles and amphibians. There are 250 plant species, including southern oak woodland, riparian woodland, chaparral, coastal sage scrub, desert scrub, California grassland, and freshwater marsh. (Courtesy Stagecoach Inn and Conejo Valley Historical Society.)

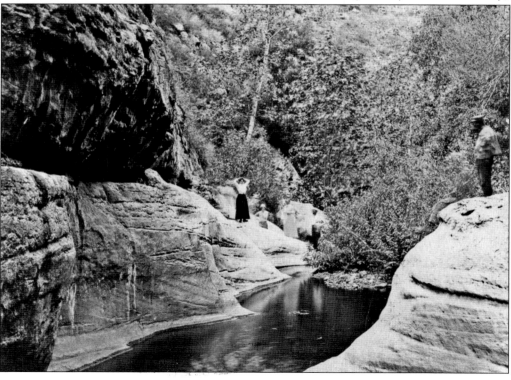

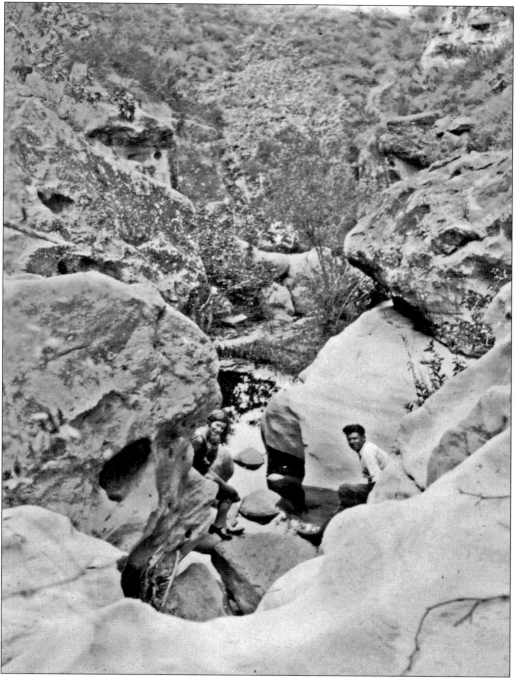

The Wildwood area served as the backdrop for many movie and television episodes, including *Spartacus*, *Wuthering Heights*, *Wagon Train*, *The Rifleman*, and *Gunsmoke*. (Courtesy Thousand Oaks Library, accession number LHP01101.)

Lake Sherwood was carved out and filled by F. W. Mathiesson in 1905. Mathiesson purchased the Banning Company, which purchased the acreage from Joseph Howard.

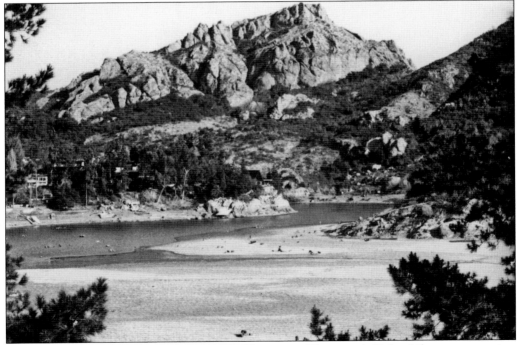

Lake Sherwood was drained in 1984. (Courtesy Thousand Oaks Library, accession number LHP00501b.)

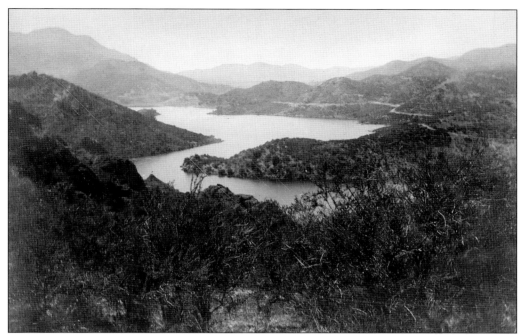

The lake changed names several times, including Lake Canterbury, named for Mathiesson's divorced wife, who took on the last name of her new husband. In 1929, the name was changed to Los Touras Lake, a name derived by combining the counties of Los Angeles and Ventura. Lastly, the name Lake Sherwood was applied in honor of the *Robin Hood* movie that was filmed nearby. (Courtesy Stagecoach Inn and Conejo Valley Historical Society.)

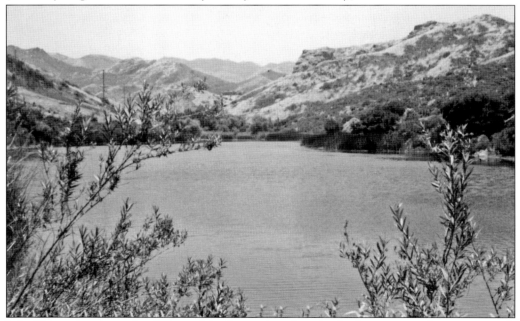

Lake Eleanor was created in 1889, and the dam is thought to be the first concrete dam ever poured. (Courtesy Thousand Oaks Library, accession number LHP00882b.)

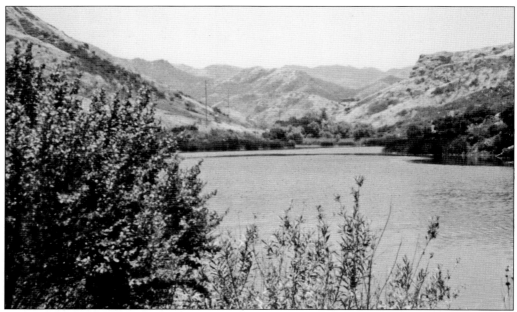

The acreage for Lake Eleanor was sold by Joseph Howard to the Banning Company in 1888. The Banning Company was based out of Long Beach and included Katherine, Anna, Ophelia, William, Josef, and Hancock Banning. Their father, Phineas Banning, founded the city of Wilmington and had interests in shipping, warehousing, and real estate. The family also owned part of Santa Catalina during this period but later sold it to William Wrigley. (Courtesy Thousand Oaks Library, accession number LHP00882a.)

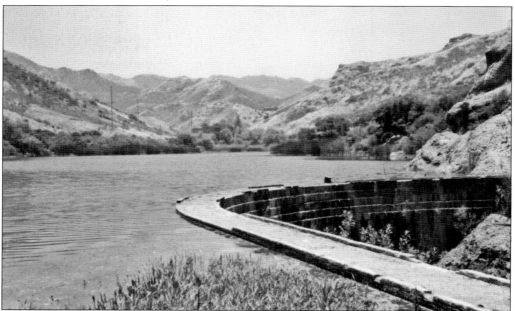

Sometimes listed as the Banning Dam or the Lake Eleanor Dam, the lake contains 8 acres with 529 acres of open land. The dam is owned by the Conejo Open Space Conservation Agency. (Courtesy Thousand Oaks Library, accession number LHP00888.)

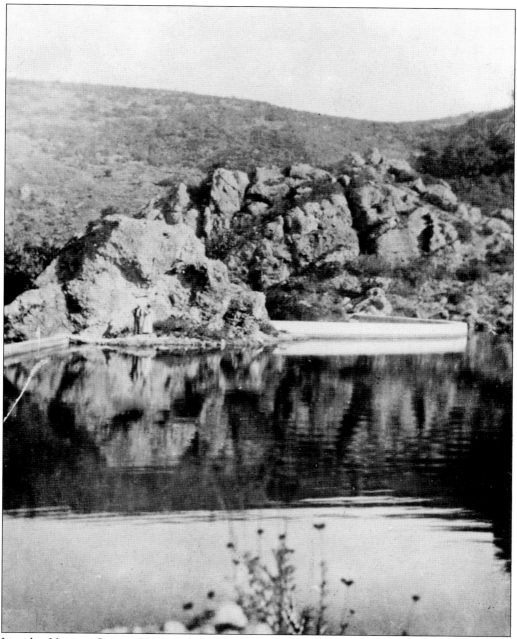

Listed as Ventura County Historical Landmark No. 120 in May 1988, the City of Thousand Oaks made it point of interest No. 9. The dam is in a gorge with sheer cliffs and drops of 40 to 50 feet. (Courtesy Stagecoach Inn and Conejo Valley Historical Society.)

Richard Orville Hunt takes a break at Lake Matthiesson. The Hunt family's roots in America can be traced back to the 1620s. Born in Maine in 1832, Hunt followed his brother, Col. Charles C. Hunt, out west and landed in Santa Barbara in 1870. Though Hunt purchased his land in 1876, the year before the start of the drought, he leased his land for 12 years before relocating to the Conejo, thus avoiding the losses most other ranchers faced. (Courtesy Stagecoach Inn and Conejo Valley Historical Society.)

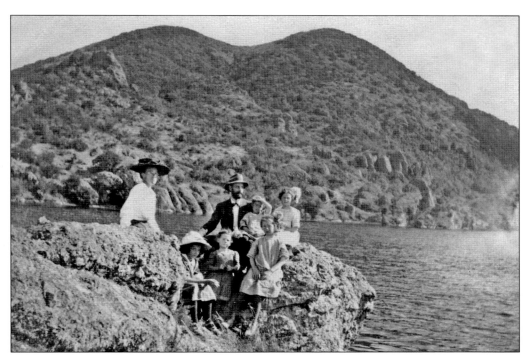

The Hunt family takes in a view of Lake Matthiessen around 1910. (Courtesy Stagecoach Inn and Conejo Valley Historical Society.)

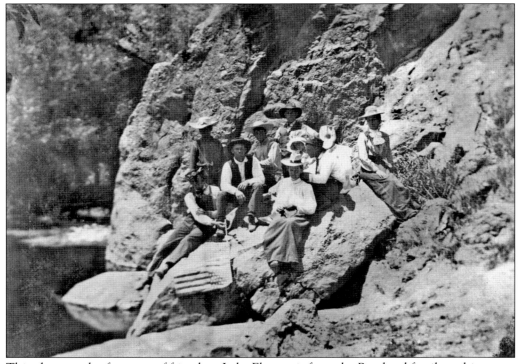

This photograph of a group of friends at Lake Eleanor is from the Borchard family archives.

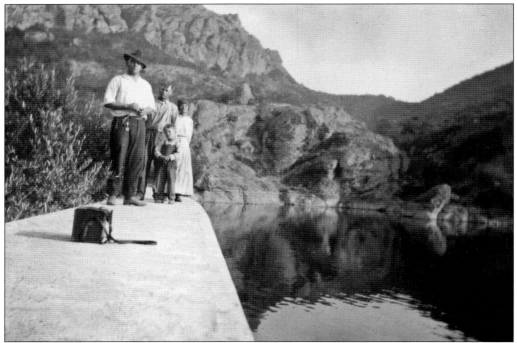

From the Hays family photo album, William Washington Hays, Susan Hays, and friends visit Lake Canterbury (later Lake Sherwood) around 1910.

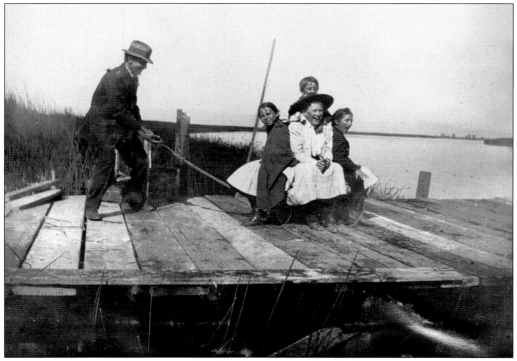

An unidentified family gets a ride in a stroller on the pier at Lake Sherwood around 1920.

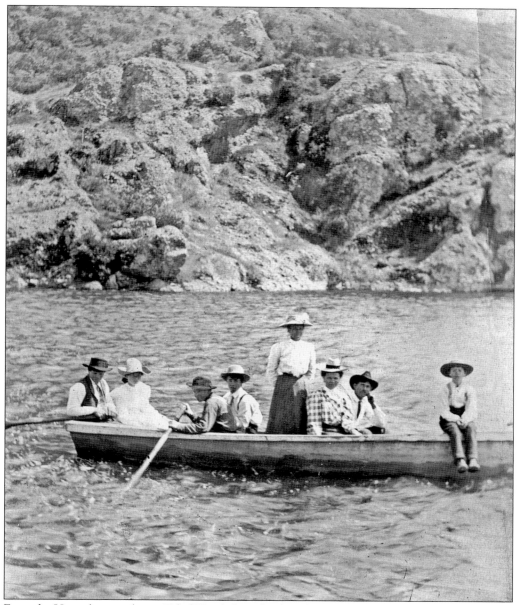

From the Hays photo archives, Ethel Haigh (standing) and friends take a boat ride at Lake Eleanor around 1910. Sometimes photographs appear in more than one source. This same photograph appears in the Borchard photo albums as well.

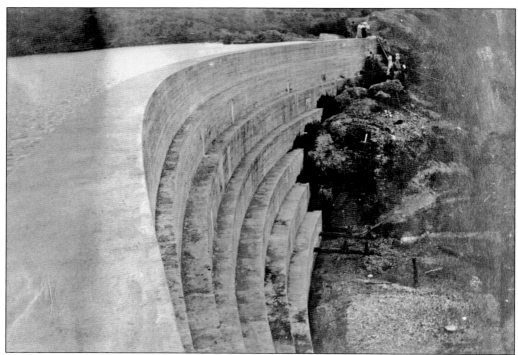

The Borchard cousins use a rope to climb up the backside of Lake Eleanor around 1905.

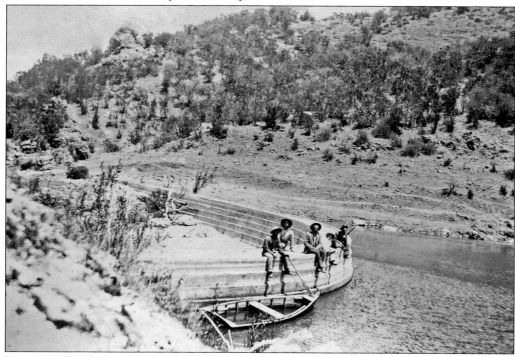

Henry Maulhardt (center) takes a break from his Ocean View ranch with his crew for an afternoon outing at Lake Matthiessen around 1910.

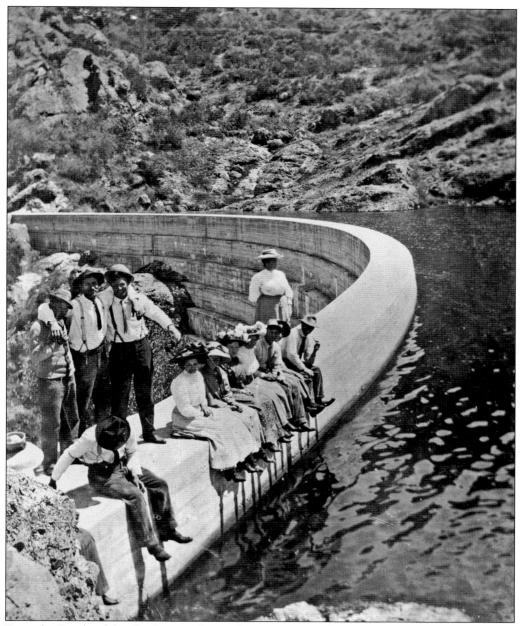

From the Borchard family photo archives, this is a picture of a group of friends at Lake Eleanor around 1905.

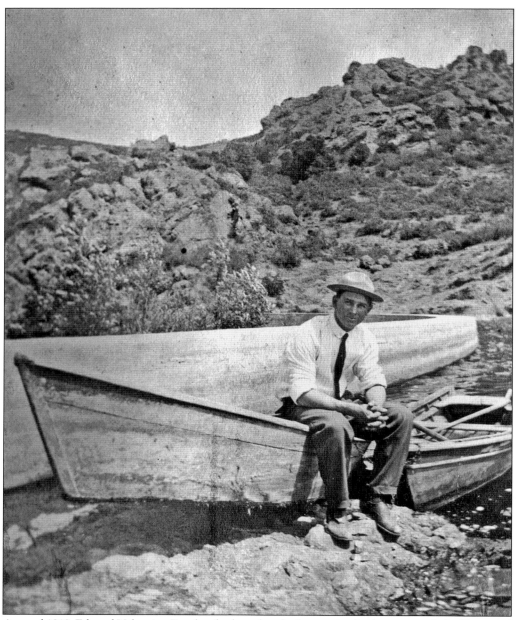

Around 1910, Edward Valentine Borchard takes a break after rowing his boat across Lake Sherwood in his long pants and shirt and tie. Borchard was born in Cincinnati, Ohio, as part of the Cincinnati Borchards. His family owned a harness business, and his father, Henry, was a cousin to Caspar Borchard Sr. Ed came to California in 1906 and worked at the American Beet Sugar Factory in Oxnard. By 1907, he was working for Caspar Borchard Sr. By 1910, he was married to Caspar's youngest daughter, Teresa.

Teresa Borchard hands the camera over to her husband, Ed, and she poses while dressed in her Sunday best. Teresa and Ed had five children, Margaret, Edward, Robert, Rita, and Alan. They farmed the Johannes Borchard Ranch, as well as land Teresa inherited from her father.

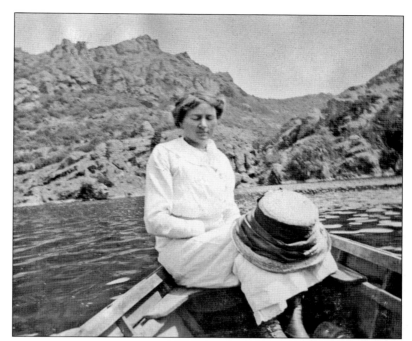

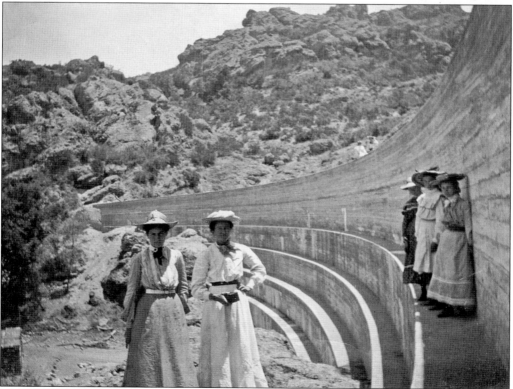

Mary Borchard (second from left) and a friend pose while Teresa (far right) and friends stand at the base of the Lake Eleanor Dam around 1905.

The Dayton Realty Group proposed a large development in May 1984. This image was taken at Lake Sherwood. (Courtesy Thousand Oaks Library, accession number LHP00501.)

Resident Kay Botzum is pictured here on November 21, 1953. (Courtesy Thousand Oaks Library, accession number LHP00816.)

Five

POST OFFICE BOX, SCHOOLS, HOTELS

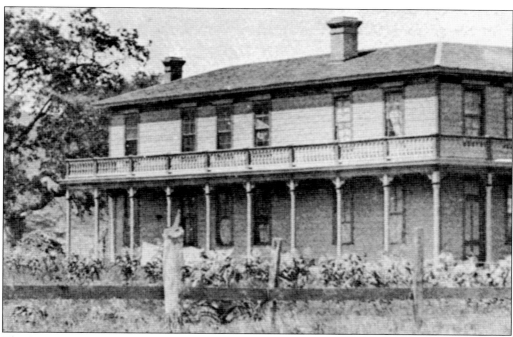

The Stagecoach Inn was originally named the Grand Union Hotel and was built in 1876 by James Hammell at a cost of $7,200, a large sum in those days. The Monterrey-style hotel was to be a rest stop for the proposed stage line that was to run through the valley. Soon after Hammell began construction, the plans for the stage route were changed. The hotel was completed, and Hammell sold the area as a resort and offered small lots for anyone interested in building a cottage near the hotel. The area became known as Timbersville.

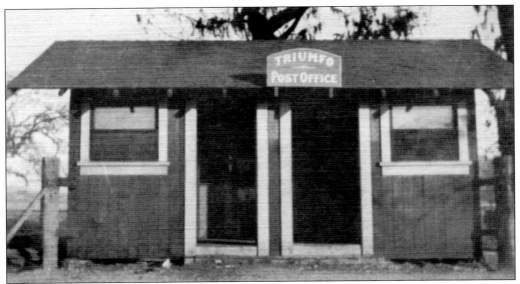

The Triunfo Post Office was established on the Russell Ranch in 1915 by Hubbard Russell. The original post office was only a few hundred yards from the Russell home, and after two years, the location was reestablished near the El Camino Real road, close to present-day Westlake Boulevard and Highway 101. Sammy Martin served as the first postmaster.

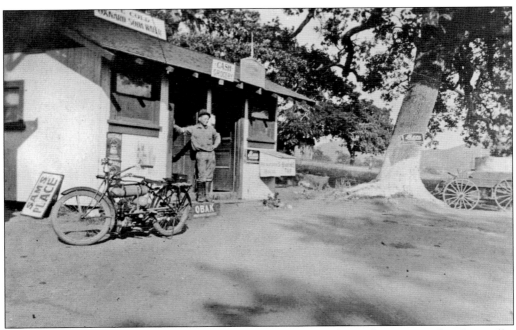

The second Triunfo Post Office lasted until 1936, at which time the mail was rerouted to Camarillo. The last postmaster was Irving Stollmack, who after serving for nearly five years, was convicted of two counts of receiving stolen property and storing truckloads of groceries for several men out of Los Angeles. While serving his prison time, Stollmack studied law and eventually became a lawyer. (Courtesy Stagecoach Inn and Conejo Valley Historical Society.)

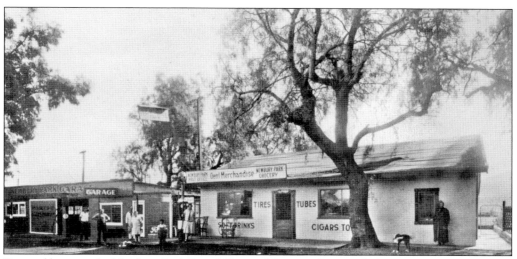

Pictured here are the Newbury Park Post Office and Grocery Store with the Union Gas Station and a campground around 1920. (Courtesy Stagecoach Inn and Conejo Valley Historical Society.)

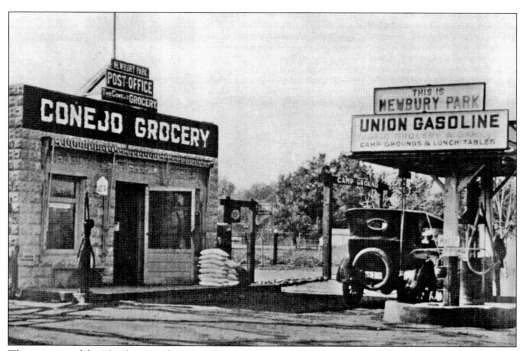

This picture of the Newbury Park Post Office and Grocery Store was taken in the 1950s and is from the Ethel Haigh Hays archives. (Courtesy Stagecoach Inn and Conejo Valley Historical Society.)

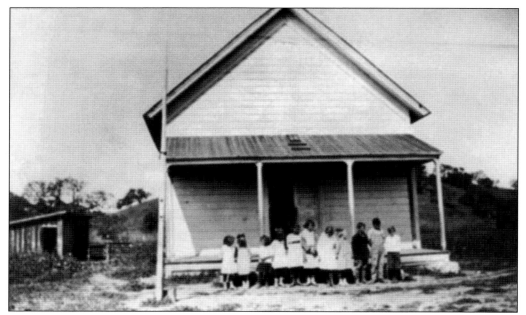

The Conejo School was established in 1877. The building was constructed by Saticoy carpenter William Richardson and was located on 2 acres donated by Howard Mills, which was soon after part of the Russell Ranch. To keep the school open, the attendance requirement was 5.5 pupils. It is not certain if there were five regular-size students and one half-size or five full-day students with one half-day scholar. The school was reputedly open until 1927, but a second date claims 1929. (Courtesy Stagecoach Inn and Conejo Valley Historical Society.)

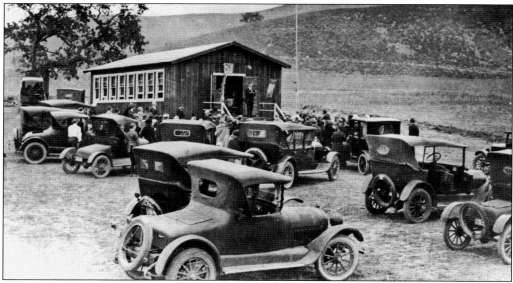

A second Conejo school was built closer to Thousand Oaks, with some references recording the date as early as 1923. A Conejo historian noted that two Conejo schools operated at the same time for several years, which affirms the early-1920s date. The automobiles also date to the early 1920s. This photograph shows Conejo residents attending a church service at the school. (Courtesy Thousand Oaks Library, accession number LHP1025.)

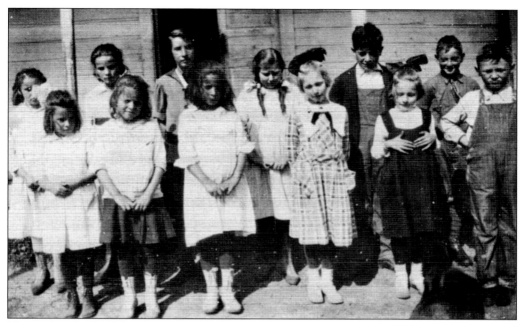

The student body of the 1920 Conejo School averaged 11 students. The teacher was Eliza Jensen, who taught the students about the evolution of the ugly caterpillar to a beautiful butterfly. Another teacher, a Mr. Ingram, preferred sports and Edgar Allen Poe's literature. He also incorporated the dunce cap and stool as one of his consequences for the students. (Courtesy Stagecoach Inn and Conejo Valley Historical Society.)

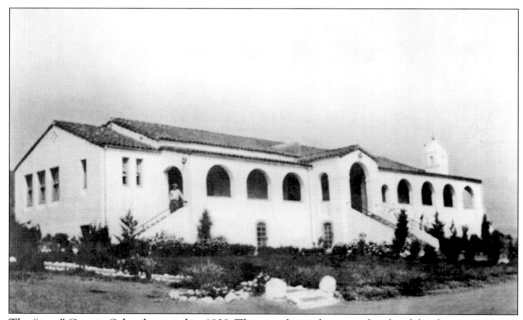

The "new" Conejo School opened in 1929. The popular architectural style of the day was Mission Revival. (Courtesy Stagecoach Inn and Conejo Valley Historical Society.)

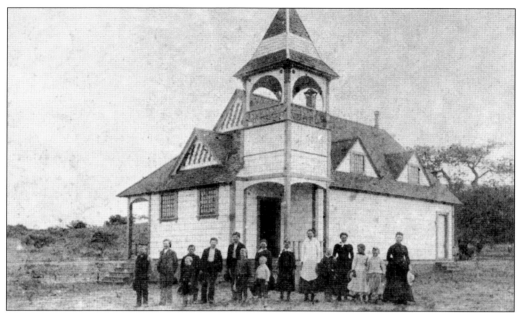

The original Timber School was located at the corner of Kelley Road and Newbury Road. The school was established on January 5, 1888, with the original school board consisting of Cecil Haigh, Mr. and Mrs. Orville Wadleigh, Richard Hunt, and Caspar Borchard. (Courtesy Thousand Oaks Library, accession number LHP01037.)

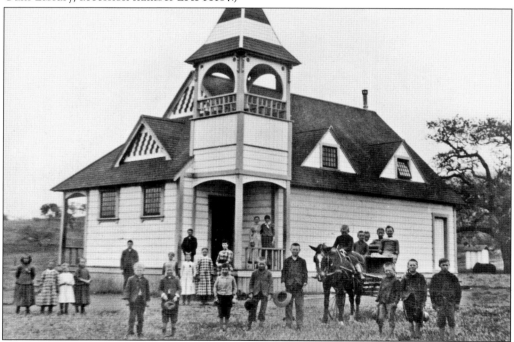

Cecil Haigh sold 2 acres for the site at a cost of $50. Similar to the Russell family trying their best to keep the Conejo School doors open, the trustees hired help who had families to ensure they would have enough students to keep the doors open.

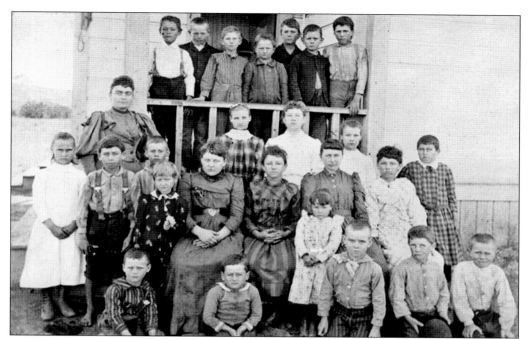

The first teacher at the Timber School was a Miss Mosher, who was paid $40 a month to teach the 22 students enrolled at the school. By the end of the year, the classroom attendance had climbed to 44 students. (Courtesy Stagecoach Inn and Conejo Valley Historical Society.)

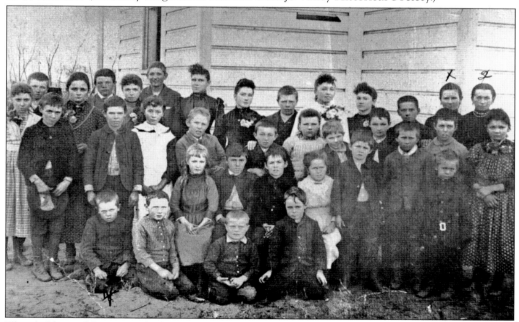

The children of Caspar and Theresa Borchard can be identified in this c. 1890s school photograph. Leo is the first boy from the left in the fourth row. The two girls in the fourth row on the right are Mary and Rosa. Casper and Frank are in the second row, standing first and second on the right. Antone and Charles are in the first row, kneeling first and third from the left.

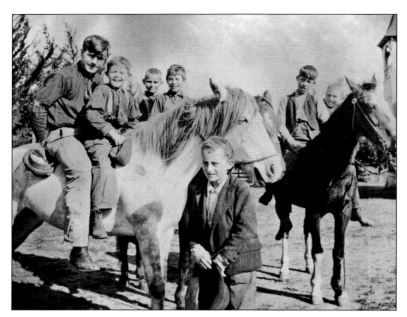

These young boys from the Timber School bypassed bicycles for horses to get to school during the days of dirt roads and long rides. The Timber School can be seen in the background. Ida Addis Storke's 1891 account of the area states, "There are here a post office, hotel, store, blacksmith shop, tannery, Chinese laundry, a good schoolhouse, and one or two church organizations."

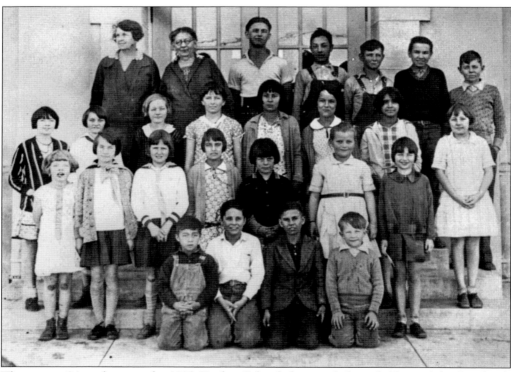

There were 24 students in the 1930 Timber School class, including children of the Borchard, Friedrich, Espinosa, Hays, and Kelley families. Maggie Parker was the teacher from 1924 to 1933. She earned a salary of $150 a month and an extra $5 for cleaning the school. (Courtesy Stagecoach Inn and Conejo Valley Historical Society.)

Katy Troy served as one of the first teachers at the Timber School. This photograph is dated 1889. For most students of the day, the *McGuffey Reader* was the main text. The reader consisted of four versions. The first emphasized phonics and letter and word recognition. A slate board and chalk were required. The second reader introduced stories, while the third was the equivalent of the fifth-grade-level teaching definitions. The fourth reader expanded on the previous lessons.

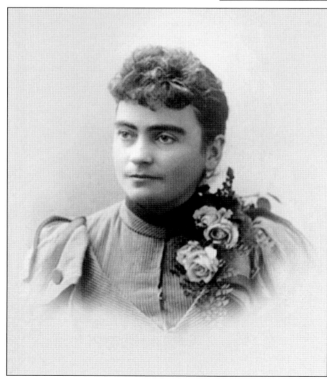

Annie M. Sullivan was the Timber School teacher in 1892–1893. Sullivan taught 28 students, whose grades ranged from first through seventh. At this time, most women earned about $12 less than their male counterparts, receiving $60 per month.

A popular item for most school kids was an autograph book. Students shared their rhyming schemes with their classmates, sometimes taking on outlandish similes that still provide amusement a century later.

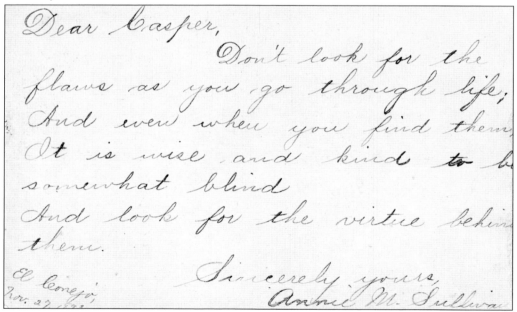

Annie M. Sullivan signed Casper Borchard's autograph book on November 27, 1893, and wrote "Don't look for the flaws as you go through life; And even when you find them, It is wise and kind to be somewhat blind, And look for the virtue behind them." This was a lesson Borchard applied in his life and passed on to his children.

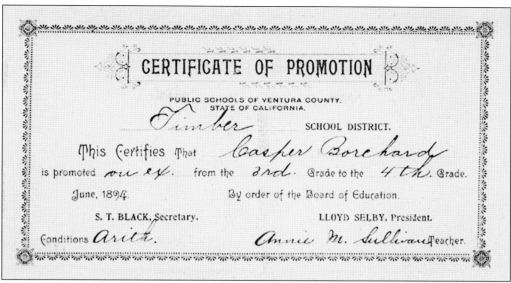

CERTIFICATE OF PROMOTION

PUBLIC SCHOOLS OF VENTURA COUNTY.
STATE OF CALIFORNIA.

Timber SCHOOL DISTRICT.

This Certifies That *Casper Borchard*

is promoted *on ex.* from the *3rd.* Grade to the *4th.* Grade.

June, 1894. By order of the Board of Education.

S. T. BLACK, Secretary. LLOYD SELBY, President.

Conditions *Arith.* *Annie M. Sullivan* Teacher.

Students received promotion certificates, and in 1894, Borchard was promoted from second grade to fourth grade. Signed by his teacher, Annie Sullivan, the "conditions" listed on the certificate was "arithmetic." It is not certain if it was because he excelled in math or needed special conditions for math; his double promotion suggests the former.

> *Dear Brother*
> *I thought, I thought, in vain;*
> *At last I thought, I would*
> *write my name*
> *Your brother,*
> *Casper*
>
> *Oct 30, 1893.*

Soon-to-be 12-year-old Borchard, in turn, shared his wisdom with his older brother, Leo, in an October 30, 1893, writing, "Dear Brother, I thought, I thought in vain, At last I thought, I would write my name."

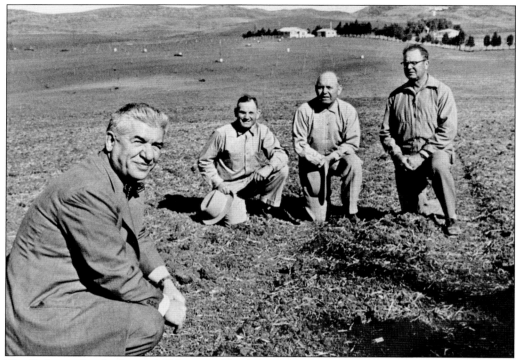

The Pederson family donated 130 acres of land for the creation of California Lutheran College in 1957. The 1913 ranch home was converted into a music classroom. By 1959, the college was opened for education. Pictured in front of the future college site are, from left to right, Dr. Orville Dahl and Richard, Peder, and Lawrence Pederson. (Courtesy Thousand Oaks Library, call number 04-12-1981.)

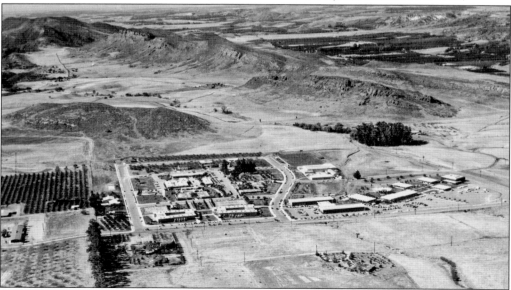

As a revenue source for the campus, the college opened up the campus in 1963 to the Dallas Cowboys for the team's summer camp. Thousands of fans flocked to Thousand Oaks to watch their favorite football team. The college joined the university system in 1986.

Cecil Arthur Entwistle Haigh took over the Grand Union Hotel in 1885, which was at this time called the Hammell House Post Office and Stage Station. Soon the hotel was called the Conejo Hotel. By 1890, Haigh was joined by Cicelie Haigh, a cousin from England, whom he married. Eventually the name was changed to the Stagecoach Inn. The inn also served as a school, post office, military school, tearoom, and antique shop. (Courtesy Stagecoach Inn and Conejo Valley Historical Society.)

Through the efforts of the Conejo Valley Historical Society, the Stagecoach Inn was moved in 1966 due to the expansion of the highway. H. Allen Hays donated the building, along with 4 acres, to the Conejo Recreation and Parks District. However, the museum burned down in 1970 in a fire of unknown origin. The rebuilt museum was dedicated on July 4, 1976. This photograph shows the Conejo Valley Historical Society at their origination meeting for the restoration of the Stagecoach Inn. (Courtesy Thousand Oaks Library, accession number 10-3-1966/1.)

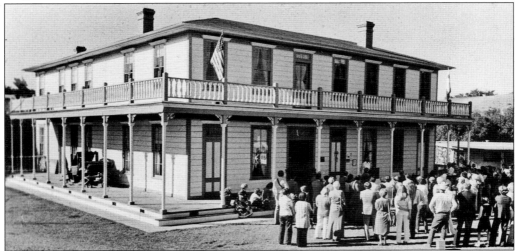

The Stagecoach Inn in Newbury Park plays host to many functions and celebrations, including this gathering in 1985. The Stagecoach Inn was designated Ventura County Landmark No. 30 in 1965 and, in 1976, as State Landmark No. 659 and placed on the National Register of Historic Places. Today the site of the inn serves as an interpretive center for several eras of California history with its Tri-Village, containing replicas of a Chumash Tule hut, a Spanish-era adobe, and a pioneer cabin. (Courtesy Thousand Oaks Library, call number 05-08-1985/1.)

Six

HORSE POWER

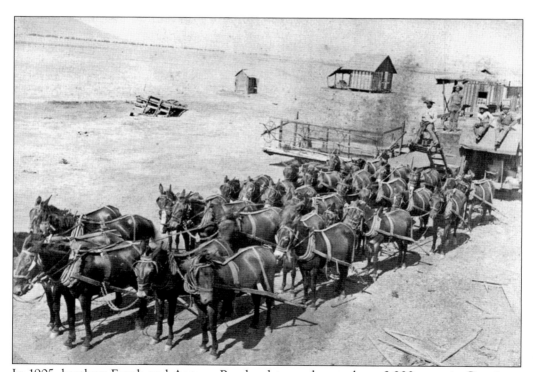

In 1905, brothers Frank and Antone Borchard teamed up to lease 3,000 acres in Conejo to farm wheat, barley, and oats. Frank worked a team of 32 horses using a Holt Harvester to reap the crops.

Will Rogers tries his hand at roping at the Borchard Ranch, where he shot a few scenes for his movie *Old Kentucky*, which was released in 1935. Other Westerns shot in Conejo Valley include *My Pal Trigger* (1946), starring Roy Rogers; *Dodge City* (1939), starring Errol Flynn; *Cattle Town* (1952), starring Dennis Morgan; *Man in the Saddle* (1951), starring Randolf Scott; *The Lone Ranger* (1956), starring Clayton Moore; *Man Without a Star* (1955), starring Kirk Douglas; *The Man Who Shot Liberty Valance* (1962), starring John Wayne; *Shenandoah* (1956), starring James Stewart; and many of the Hoot Gibson and Hopalong Cassidy films. (Courtesy Stagecoach Inn and Conejo Valley Historical Society.)

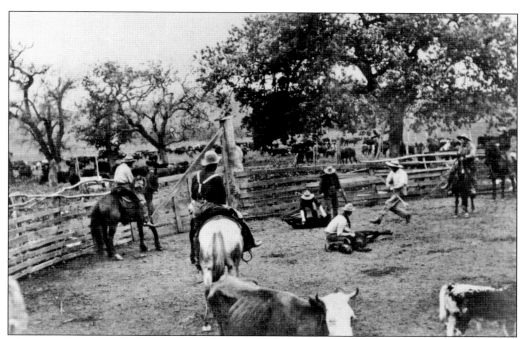

The Russell cattle were corralled at the Silo corral on the Russell Ranch or Skeleton corrals near Skeleton Canyon. The corrals were used for branding, dehorning, castrating, and vaccinating the cows. (Courtesy Stagecoach Inn and Conejo Valley Historical Society.)

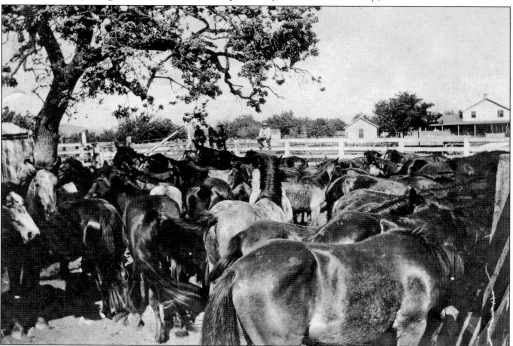

The Borchard corral, pictured around 1910, was used more for horse herding, where the horses were tended to before being used to run the threshing machines.

Andrew Russell gives some pointers to his grandson Joseph Russell Jr., who takes the reigns on their horse Babe. (Courtesy Stagecoach Inn and Conejo Valley Historical Society.)

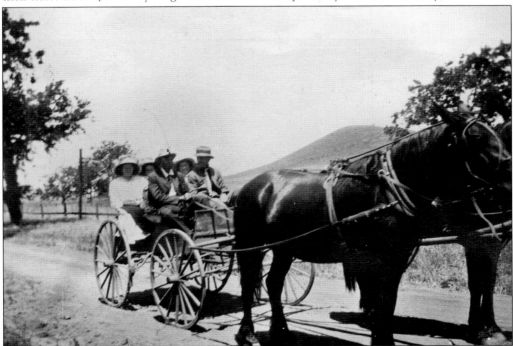

This photograph from the Borchard photo album is labeled "Ballard Canyon." The background looks very similar to the Ethel Haigh Hays photograph on page 98.

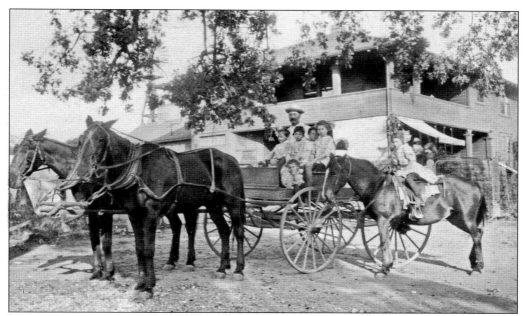

There was never a problem getting a sturdy carriage at the Hunt residence. R. O. Hunt used his blacksmith skills in Santa Barbara for several years and earned enough money to buy his Conejo ranch. Their 1910 home can be seen the background. (Courtesy Stagecoach Inn and Conejo Valley Historical Society.)

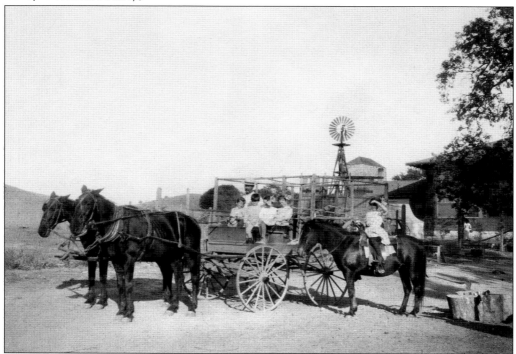

The next generation of the Hunt family is seen here ready for a ride on a sunny day. (Courtesy Stagecoach Inn and Conejo Valley Historical Society.)

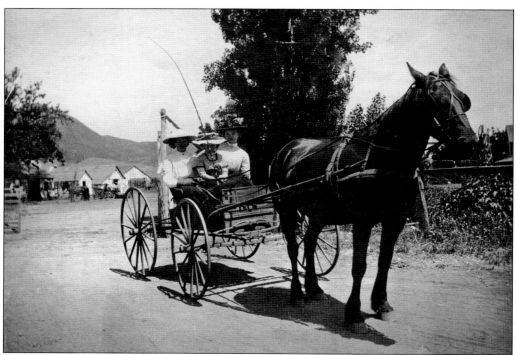

Teresa Borchard (left) and her two lady friends strap on their Sunday bonnets as they leave the Caspar Borchard Ranch.

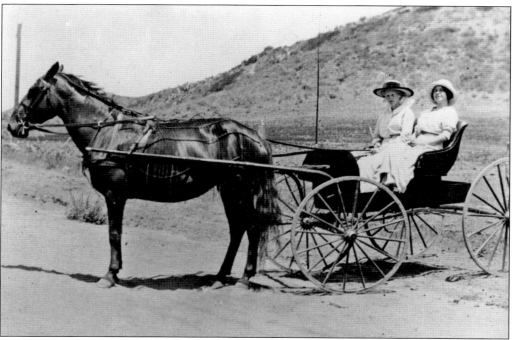

Ethel Haigh Hays (left) and a friend take a ride in her horse-drawn carriage around 1910. (Courtesy Stagecoach Inn and Conejo Valley Historical Society.)

Belle Fletcher Holloway is seen here at dry Lake Sherwood. (Courtesy Thousand Oaks Library, accession number LHP0519.)

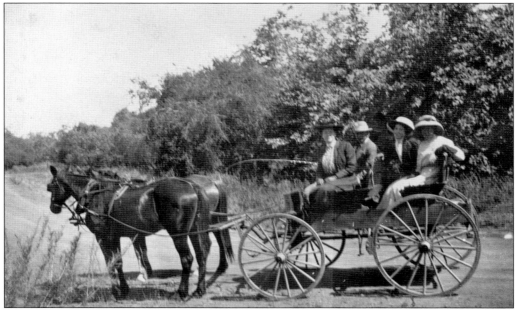

Unidentified Conejo residents are pictured here ready for a Sunday ride, because the six other days of the week were filled with endless chores to make ends meet.

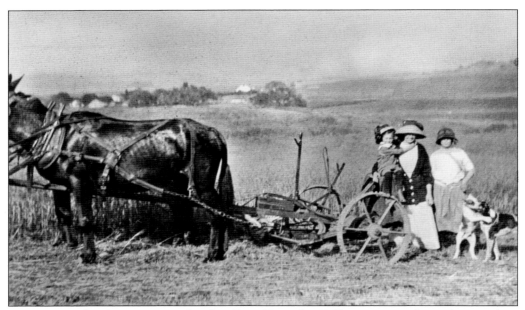

Farming on the Conejo was a family effort. Here the Kelley women take a plow to their ground in preparation for their grain crop. (Courtesy Stagecoach Inn and Conejo Valley Historical Society.)

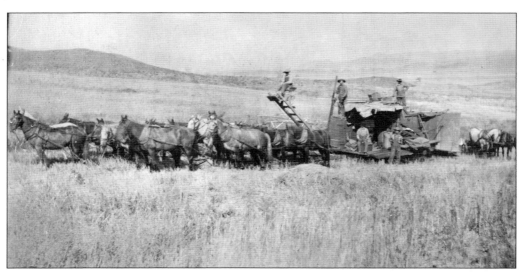

This image depicts grain harvesting at the Crowley Ranch. Green Crowley persuaded his son Henry Crowley to leave the Norwalk area and farm with his father. (Courtesy Thousand Oaks Library, accession number LHP00413.)

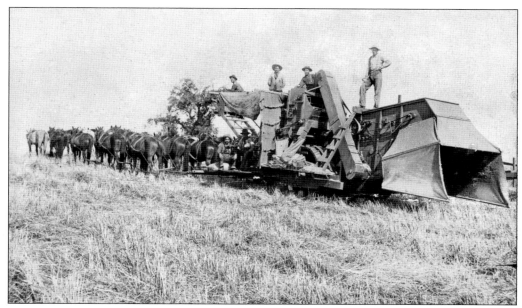

Here is a picture of grain harvesting at the Crowley Ranch, taken by the Garden City Photo Company. Three generations of Crowleys farmed on the Conejo. The houses of the Crowley Ranch are two of the oldest remaining buildings in the area. Built in 1910 and located at 2522 Pleasant Way in Thousand Oaks, the home was used as the first real estate office, which led to the birth of Thousand Oaks. (Courtesy Thousand Oaks Library, accession number LHP00411.)

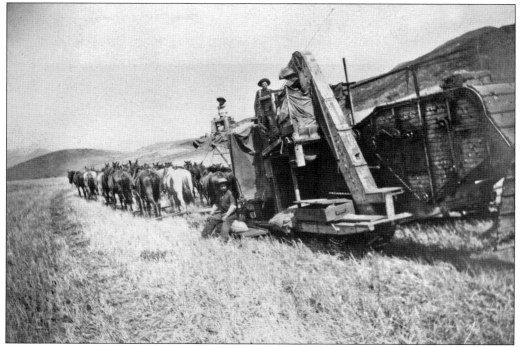

The Borchard thresher and a 24-horse team farm a portion of the available 8,000 acres that the two Borchard families owned.

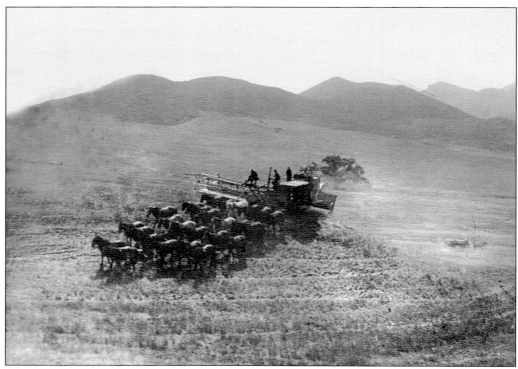

The four pictures on these two pages show different formations that the horse-driven threshers took on. The 24-horse team looks like a team of synchronized swimmers on the Conejo mountainside.

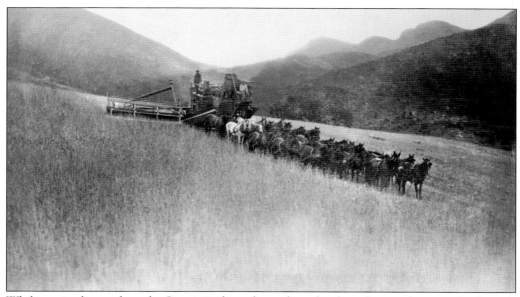

While grazing livestock on the Conejo in the early ranching days brought varied success, dry farming could be just as risky. However, for most years, the grain crops flourished in the dry climate.

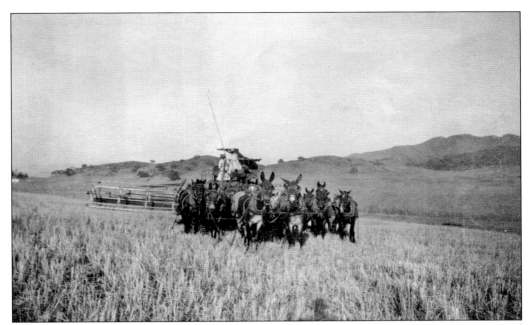

There are many advantages to dry farming, including a short growing season. If seeds are sowed in the spring, a minimal amount of rain is needed to initiate the growing process, and all plants secure most of their nitrogen in the early part of the growing period, and from nitrogen, protein is formed.

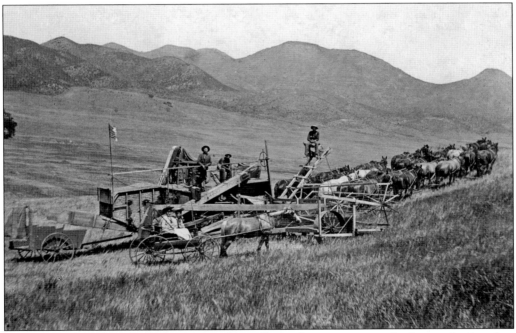

Dry farming crops are high in protein, thus offering better nutrition for livestock. Another benefit of dry farming is that the dry crop enhances the soil content by returning nitrogen back to the subsurface.

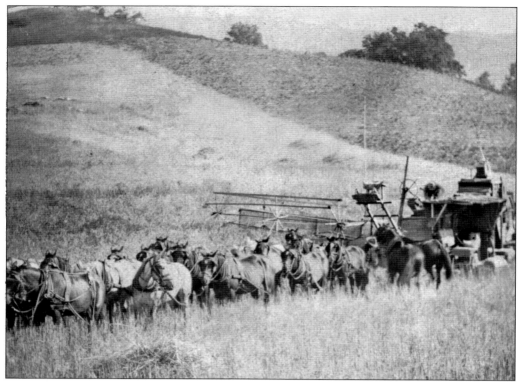

This view of grain threshing was taken at the Hunt Ranch in 1914. The cut or unthreshed grain would be placed on belts that delivered it to a set of blades, which would knock the grain off of the stalk, separating it from the chaff, or chopped straw. (Courtesy Thousand Oaks Library, accession number LHP00292.)

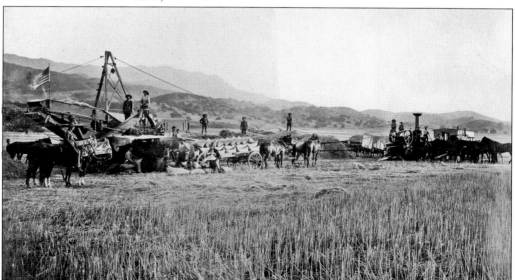

Orville A. Wadleigh began farming in Conejo in 1889. He farmed the Edwards's property for 40 years, and according to Joe Russell in his book *Cattle on the Conejo*, "never had a written contract."

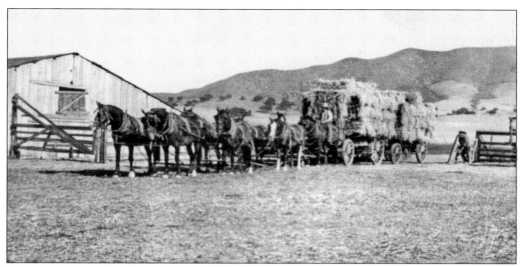

Susan Hays was the widow of Elijah Hays. The Hays family departed from Texas and traveled to California. By the time they arrived in Los Angeles, Elijah, his daughter, his two sisters, and a sister-in-law had all died from the small pox epidemic that raged through Los Angeles. The first epidemic was in 1877, and a second epidemic broke out in 1885. (Courtesy Stagecoach Inn and Conejo Valley Historical Society.)

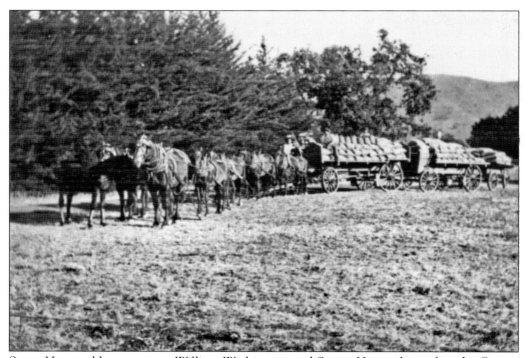

Susan Hays and her two sons, William Washington and Simon Hays, relocated to the Conejo Valley and Timberville area. By 1902, the two brothers had purchased the Haigh property. (Courtesy Stagecoach Inn and Conejo Valley Historical Society.)

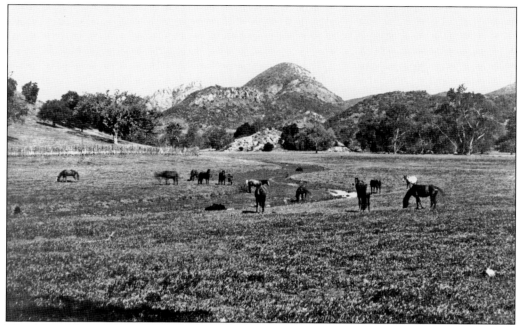

The 1880s Howard Ranch was located in what became known as Hidden Valley. After the Banning family purchased the acreage and built the Banning/Eleanor dam, farmers in the area had access to water to help overcome the dry years. (Courtesy Thousand Oaks Library, accession number LHP00550.)

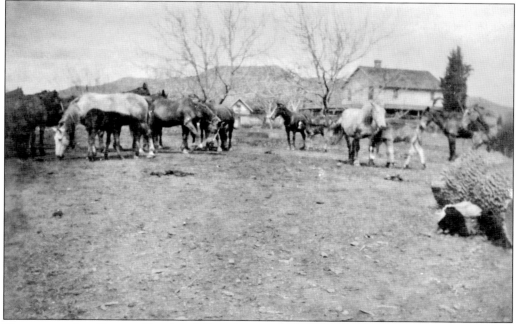

Horses on the Caspar Borchard Ranch search for a rare blade of grass on the dry Conejo landscape.

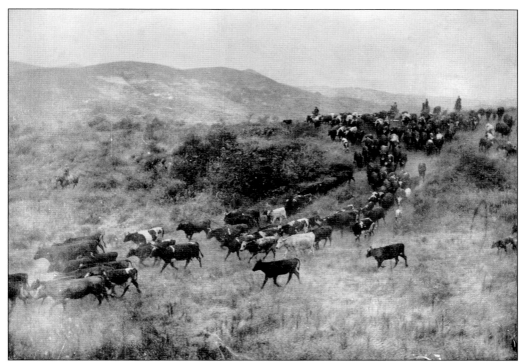

Here is a picture of cattle on the Conejo from the Borchard family archives.

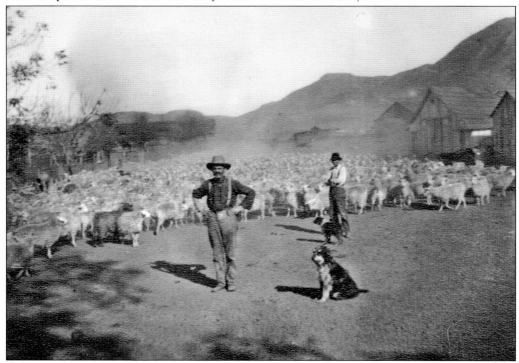

This image shows sheep on the Conejo at the Caspar Borchard Ranch around 1900.

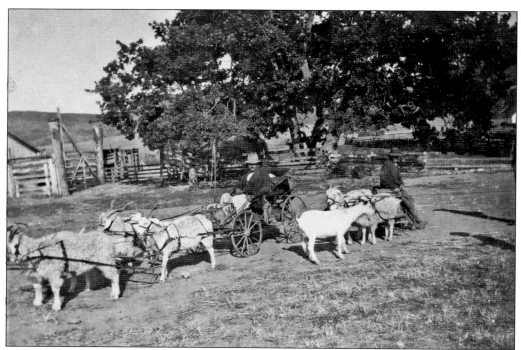

Around 1900, a worker on the Caspar Borchard ranch uses a team of four goats to run errands on the ranch while Charles Borchard waits his turn.

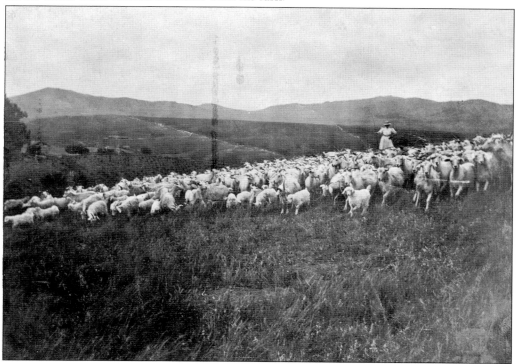

The Friedrich family used the rolling hills of their Conejo acreage to graze a herd of sheep.

Charles Borchard, the youngest son of Caspar and Theresa Borchard, uses a rope and his brute strength to influence a stubborn donkey. The male donkeys were used to breed with female horses to produce mules. Mules are more patient, sure-footed, and hardier than horses.

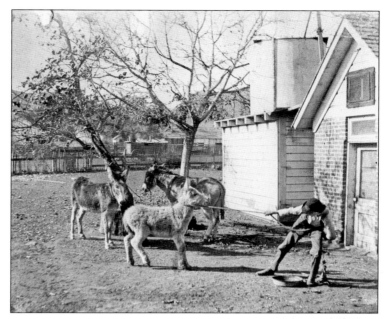

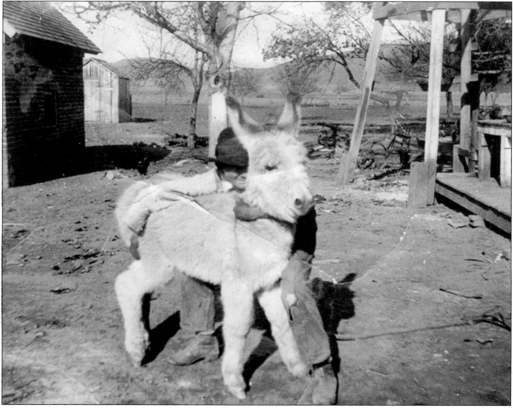

Abandoning the rope for brute strength, Charles Borchard gets personal with a young donkey at his father, Caspar's, ranch. Donkeys are more obstinate, slower, and less intelligent than mules.

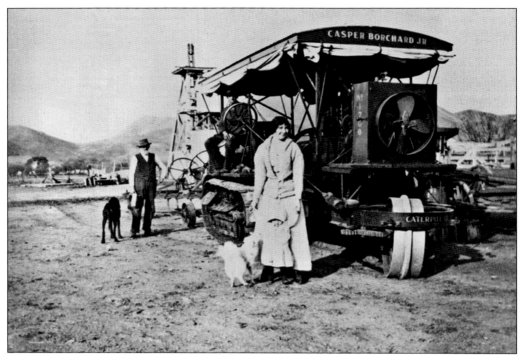

Ida Borchard, with one of her children, stops by to pay a visit to her husband, Casper Borchard Jr., on his Hold 60 Caterpillar, while his father, Caspar Borchard Sr., stands by with some advice. Casper Jr. purchased the tractor in 1912. It was one of the first gasoline-powered track-type tractors.

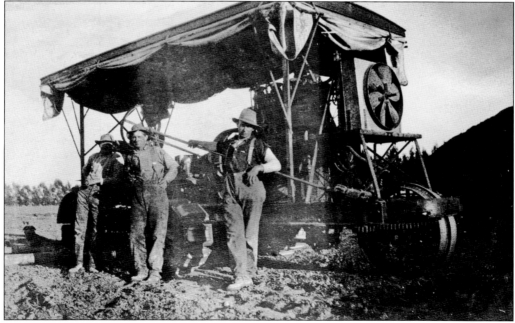

Ed Borchard (center) uses his gasoline-powered Holt 60 Caterpillar to work some land on the Oxnard Plain.

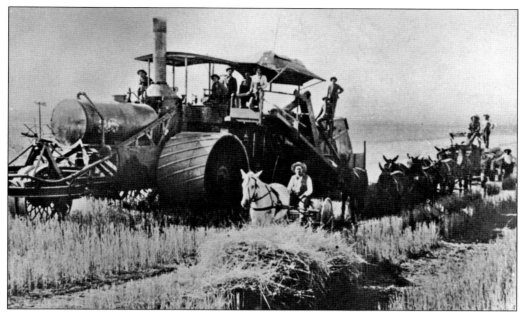

O. A. Wadleigh's enormous steam-powered Case tractor dominated the landscape when he and his crew took on a field of grain crops. Tractors of this type weighed approximately 24,000 pounds with a 74-horsepower engine and wheels measuring 5-feet-by-6-inches wide. Wadleigh is seated in the carriage drawn by the white horse. (Courtesy Stagecoach Inn and Conejo Valley Historical Society.)

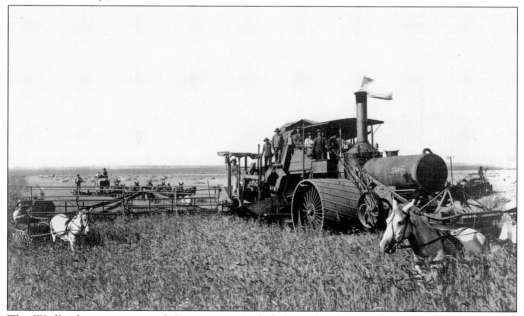

The Wadleigh steam-powered Case tractor included two bunkers at the back of the tractor for storing fuel and wood to heat the 43-inch-diameter boiler barrel. The steam-powered tractor peaked in 1912 and, by 1924, was overtaken by the gas-powered tractor. (Courtesy Stagecoach Inn and Conejo Valley Historical Society.)

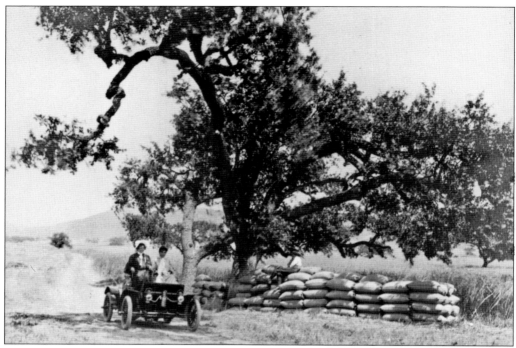

Reba and Henrietta Russell are riding in an automobile as Joe Russell, sitting on top of grain sacks, looks on. (Courtesy Thousand Oaks Library, accession number LHP02551.)

Members of the Borchard family travel down the Conejo and past the "Advertising rock" on the Conejo grade. From left to right are (back seat) Casper Borchard and Ida Ayala Borchard; (front seat) Antone Borchard (driver) and Anna Kellner Borchard.

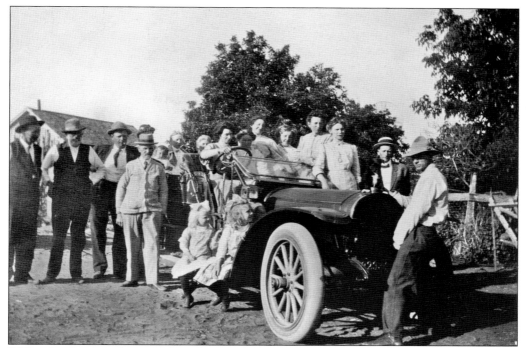

Ed Borchard gets ready to crank up the engine of a 1910 Buick at the home of Johannes Borchard. On the far left is Louis Maulhardt, who is standing next to Caspar Borchard. The man in the white sweater is Cincinnati's Henry Borchard. He came to Oxnard for the wedding of his cousin. The Borchard cousins man the machine.

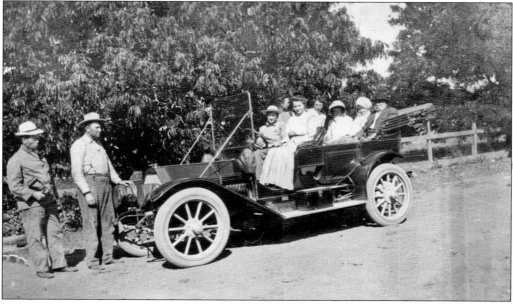

Breakdowns were common with early automobiles. Johannes Borchard is seated in the back seat. Also present are Franz Borchard, who recently came from Germany, in the front seat and Annie Borchard, standing in the back. This image is from around 1910.

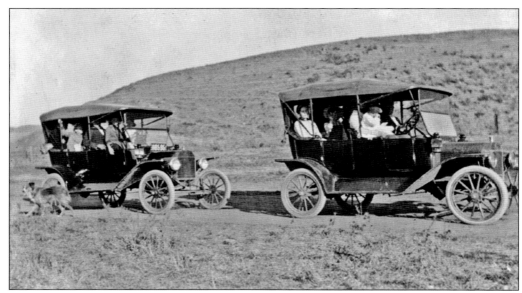

The Scholle brothers, cousins of the Borchards, bought two Ford Model Ts, which they used to transport their cousins across the Conejo.

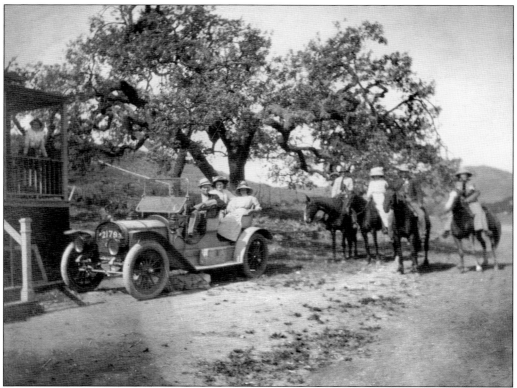

Leo Borchard returns to the Conejo from the Talbert area with his new horsepower to visit his brother Casper.

Seven

LADIES OF THE CONEJO

Henrietta Stahmer Russell was married to Joe Russell. They met while attending Los Angeles High School and were married in 1908. They raised three children, Margaret Elizabeth, Henrietta Patricia, and Joseph Hutchinson Russell. (Courtesy Stagecoach Inn and Conejo Valley Historical Society.)

Catherine Mills Clapp was the daughter of Howard and Caroline Freeman Mills, who came to California in 1870. The Mills had three children, Mary Estes, Emily Catherine, and Anna. The parents returned to Minnesota and bought a home; however, Caroline's illness persisted, and Mills returned to California without his wife. Caroline died on August 17, 1874. (Courtesy Stagecoach Inn and Conejo Valley Historical Society.)

Cicelie Haigh was the wife of Cecil Haigh, who ran the Grand Union Hotel. She raised four children and was instrumental in keeping the hotel in business. (Courtesy Stagecoach Inn and Conejo Valley Historical Society.)

Abigail Russell was married to Andrew Russell. She was instrumental in organizing and keeping the first area school, the Conejo School, open. She encouraged her husband to hire men with families. She would even take her carriage to neighboring ranches, including the Ballard Ranch, where several of the African American children would eagerly hop on board for a ride to the Russell Ranch for some schooling. The 1929 Conejo School was dedicated in her honor. (Courtesy Stagecoach Inn and Conejo Valley Historical Society.)

Ethel Haigh Hays was the daughter of Cecil and Cicelie Haigh. Ethel married Simon Hays after his cavalry service during World War I. They bought the Stagecoach Inn from her mother. They had two children, Reba Hays Jefferies and Allen Hays. It was Allen who donated the hotel and 4 acres in 1966 for the conservation of the Stagecoach Inn.

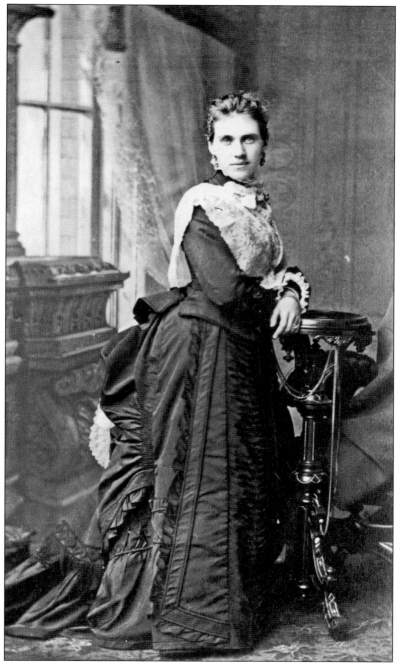

Frances Kellogg Newbury (1848–1917) married Egbert Starr Newbury in San Francisco in 1873. Traveling down the coast to the Conejo, the Newburys built a house and barn. Frances helped run the area's first post office, which started as a tent. Their stay was short but groundbreaking, as they saw the area build a park and their post office became the Newbury Park post office. Frances gave birth to four children, three of whom lived to adulthood. (Courtesy Stagecoach Inn and Conejo Valley Historical Society.)

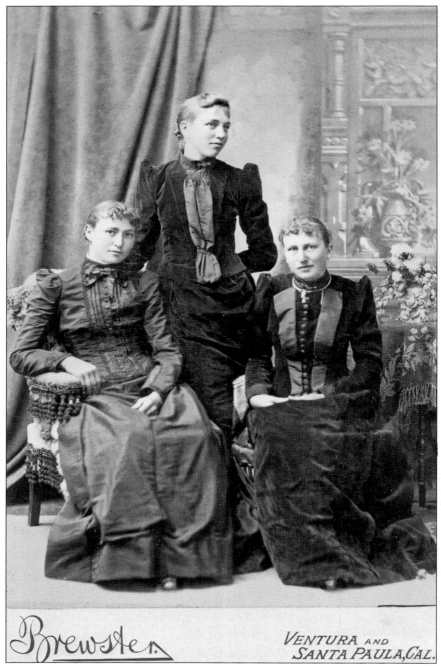

Brewster.

VENTURA AND SANTA PAULA, CAL.

This picture of the daughters of Johannes Borchard was taken around 1893. Johannes owned 4,000 acres that became known as Rancho Sierra Vista. The daughters inherited the property from their father and leased a portion of it to their cousins Ed and Teresa Borchard. In 1937, they sold the property to Carl Beal. His heirs sold the land to Richard Danielson. Danielson sold the area to the Point Mugu State Park in 1972. Pictured here are, from left to right, Mary Borchard Fasshauer, Theresa Borchard Maulhardt, and Annie Borchard Friedrich.

This photograph of the daughters of Caspar Borchard was taken around 1910. Pictured here are, from left to right, Teresa, Rosa (sitting), and Mary. Teresa married a distant cousin, Ed Borchard from Cincinnati, and they farmed the Johannes Borchard Conejo land as well as land that Teresa inherited from her father. Rosa married Silas Kelley, and they farmed the Conejo and, for a short time, in Madera. Mary became the matriarch after her mother died in 1898 and devoted her time to her siblings and her father, and never married.

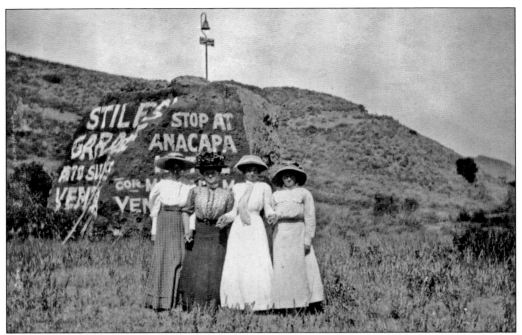

Four Conejo ladies are seen in front of "Advertising rock" and the El Camino Real sign on the Conejo grade. The two advertisements visible are for the Anacapa Hotel and Stile Garage, both in Ventura.

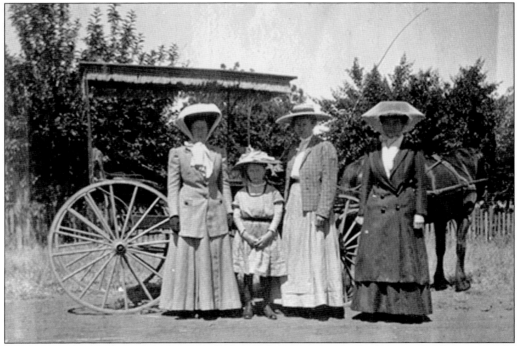

Mary Borchard (second from right) readies for a much-deserved pleasure ride with three friends.

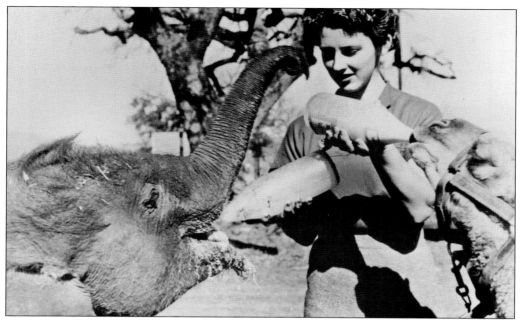

Alma Goebel, daughter of Louis Goebel, is seen here bottle-feeding a baby elephant and a baby camel at Jungleland. (Courtesy Thousand Oaks Library, accession number LHP02213.)

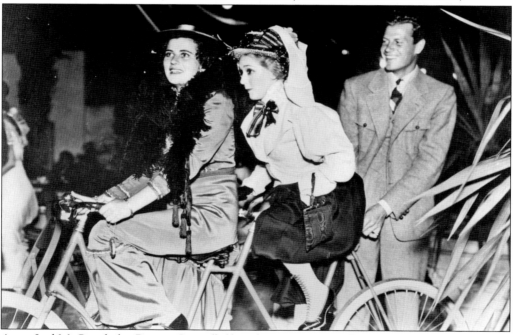

Actor Joel McCrea helps Patricia Janss (left) and actress Mary Pickford catch their balance on a double-seat bicycle. McCrea owned a 285,020-acre cattle ranch in Conejo near Moorpark Road and extending toward the Santa Rosa Valley. The ranch site was placed on the National Register of Historic Places in 1997 and is currently in the hands of the Conejo Recreation and Parks District. (Courtesy Thousand Oaks Library, accession number LHP02995.)

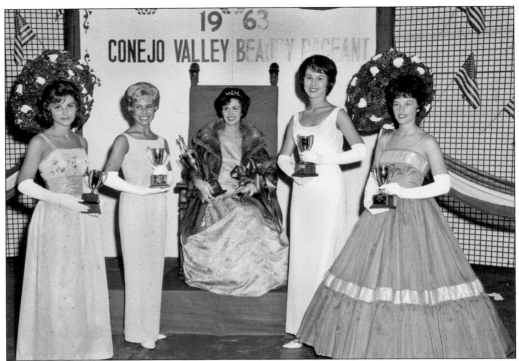

Pictured here is the Conejo Valley Beauty Pageant. Sandy Dobberstein (seated) has just been crowned Miss Conejo Valley. (Courtesy Thousand Oaks Library, accession number LHP 02213.)

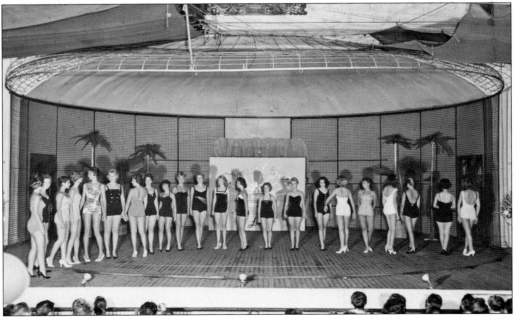

This is the Thousand Oaks 1960 beauty contest for the Honorary Mayor Day event. It took place at the main stage in Jungleland, with the wire enclosure removed for the event. (Courtesy Thousand Oaks Library, accession number LHP01667.)

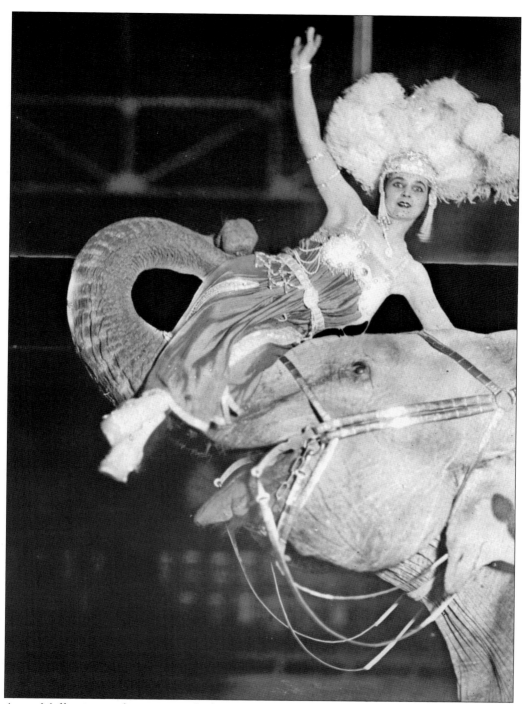

Anna Muller is seen here on an elephant's trunk. She and her husband, Rudy, were world-renowned animal trainers and circus performers. They moved to Thousand Oaks in 1946 to perform at Jungleland. The elephant may be Big Rosie. (Courtesy Thousand Oaks Library, accession number LHP01042.)

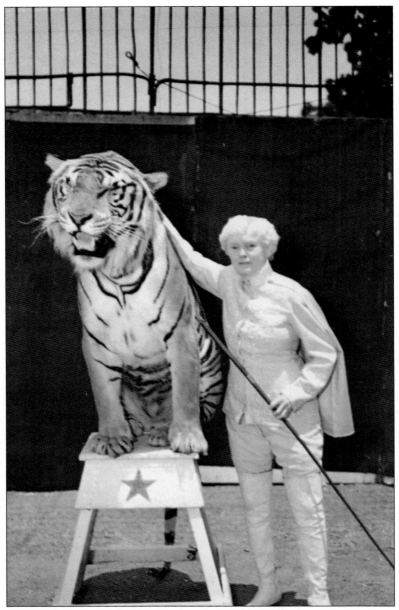

Mabel Stark was world renowned and was referred to as the world's first woman tiger trainer. Born Mary Haynie in Kentucky in 1889, Stark was with Al G. Barnes Circus by the time she was 21. Stark joined the Ringling Brothers Barnum and Bailey Circus in 1922, performed in Madison Square Garden, and was soon featured in the center ring. After traveling to Europe and Japan over the years, Stark made it to Thousand Oaks in 1938, regularly performing at Jungleland. Though she was maimed 18 times, and one time received a record 378 stitches, she worked with as many as 18 big cats at one time. She is quoted as saying, "The chute door opens as I crack my whip and shout, 'let them come,' out slink the striped cats, snarling and roaring, leaping at each other or at me. It's a matchless thrill, and life without it is not worthwhile to me." (Courtesy Stagecoach Inn and Conejo Valley Historical Society.)

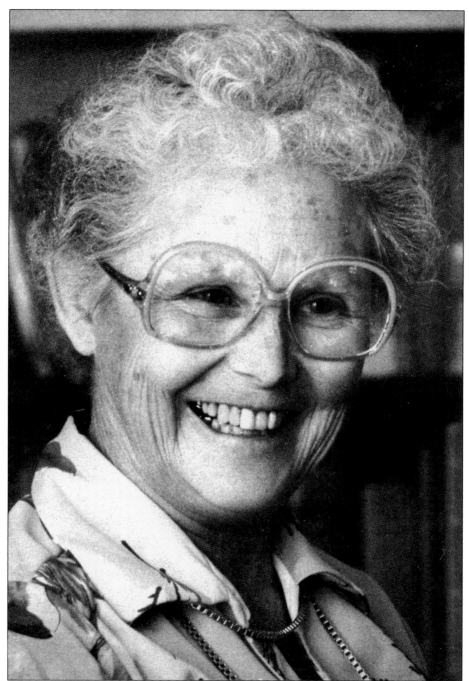

City historian Patricia "Pat" Allen enjoys a laugh, most likely about a story from Conejo's past. Allen wrote the history of Rancho El Conejo for the spring 1976 edition of the *Ventura County Historical Quarterly*, Vol. XXI, No. 3. Allen's meticulous research has provided the valley with a detailed account of the early settlers from the Rancho Period through Conejo Valley's slow growth toward the cattle rustling and dry-farming days.

www.arcadiapublishing.com

Discover books about the town where you grew up, the cities where your friends and families live, the town where your parents met, or even that retirement spot you've been dreaming about. Our Web site provides history lovers with exclusive deals, advanced notification about new titles, e-mail alerts of author events, and much more.

MADE IN THE USA

Arcadia Publishing, the leading local history publisher in the United States, is committed to making history accessible and meaningful through publishing books that celebrate and preserve the heritage of America's people and places. Consistent with our mission to preserve history on a local level, this book was printed in South Carolina on American-made paper and manufactured entirely in the United States.

This book carries the accredited Forest Stewardship Council (FSC) label and is printed on 100 percent FSC-certified paper. Products carrying the FSC label are independently certified to assure consumers that they come from forests that are managed to meet the social, economic, and ecological needs of present and future generations.

FSC
Mixed Sources
Product group from well-managed forests and other controlled sources

Cert no. SW-COC-001530
www.fsc.org
© 1996 Forest Stewardship Council

Find Your Place in History.